W9-BYF-819

MASTER LIGHTING GUIDE

for Commercial Photographers

ROBERT MORRISSEY

Amherst Media, Inc. ■ Buffalo, NY

I dedicate this book to my beautiful wife, Angie, and our darling daughter, Renya Marie Morrissey.

Special Thanks to: Justin LeVett, Tom Cassetta, Chimera, Hensel, Phase One, Jim Wills, Mike Mitchell, Murray Elliot, Amherst Media, Inc., Tim Adams, Scott Pezner, Scott Quintard, Caitlin, Susan and Eugene White, Rob Taylor, Bret Williamson, Rick Morris, and Jon Shore.

Copyright © 2007 by Robert Morrissey.
All photographs by the author unless otherwise noted.
All rights reserved.

Published by:
Amherst Media, Inc.
P.O. Box 586
Buffalo, N.Y. 14226
Fax: 716-874-4508
www.AmherstMedia.com

Publisher: Craig Alesse
Senior Editor/Production Manager: Michelle Perkins
Assistant Editor: Barbara A. Lynch-Johnt

ISBN-13: 978-1-58428-198-6
Library of Congress Control Number: 2006930067

Printed in Korea.
10 9 8 7 6 5 4 3 2 1

No part of this publication may be reproduced, stored, or transmitted in any form or by any means, electronic, mechanical, photocopied, recorded or otherwise, without prior written consent from the publisher.

Notice of Disclaimer: The information contained in this book is based on the author's experience and opinions. The author and publisher will not be held liable for the use or misuse of the information in this book.

Robert Morrissey has been behind a camera since 1988 when he first began taking classes at the Kansas City Art Institute. During the third year of his schooling, he interned with Nick Vedros, a top advertising photographer. Inspired by working with Vedros, Robert opened a studio of his own at the age of nineteen. By age twenty, he had been published all around the world. While completing his senior year, Robert not only owned and operated his own photography studio but also worked with many other professionals in the Kansas City area. He assisted these photographers, learning as much as he could from them and applying techniques he learned to his paid assignments. After graduating with a B.F.A. in photography, Robert moved on, sold his studio, and traveled through the United States and Europe, photographing everything that interested him.

After landing in Virginia Beach, Robert got a job with Wright Studios. His duties were running an E-6 lab and photographing catalog work for the Navy. This was the first time Robert was exposed to the professional digital camera. After this, Robert became a lead photographer for the University of Missouri–Columbia. In this position, he helped introduce the use of Adobe Photoshop as a tool for photographic illustration.

Photos by Kendra Adamson.

Once chosen by Phase One to be a featured photographer, Robert's career took off.

Now the owner photographer of Big Red Nose Productions, Robert shoots for international advertising campaigns, catalogs, and television commercials. You may have seen his advertising work in *National Geographic Explorer,* the *Wall Street Journal, Time,* or at your local grocery store.

You can see more of Robert Morrissey's images at bigrednoseproductions.com, where you can pose any questions you may have.

Contents

Introduction .5

Part 1. The Foundations of Commercial Lighting

1. Lighting Basics7
Types of Light .7
 Natural Light7
 Artificial Light8
Characteristics of Light10
 Color Temperature10
 Direction10
 Hard Light vs. Soft Light11
Exposure .12
 Aperture12
 Shutter Speed13
 Metering13

2. Equipment15
Cameras .15
Electronic Flash Units15
Modifiers that Attach to Flash Units16
Stands .17
Freestanding Modifiers17

3. Understanding the Diagrams20
An Overview .20

4. Studio Setup23
How to Create a Simple Product Table23
Larger Sets .24
Room Sets .25
Reflective Sets26
Creating Inexpensive Sets27

Part 2. Using Lights and Modifiers

5. Panels .30

6. Honeycomb Grids40

7. Umbrellas .46
 Using Umbrellas Outdoors56
8. Softboxes .60

Part 3. The Creative Approach

Casual Light .74
Dramatic Light77
Dappled Light78
Black & White79
Making Images Look Old80
Portraits .81
Fashion Lighting82
Corporate Portraits83
Lens Flare .84
The Creative Use of Flare86
Food .87
Rooms .88
Automobiles .94
Large Sets .98
Lighting Liquids100
Lighting on Location102
Medical Light104
Scientific Light106
Overhead Light, Part 1108
Overhead Light, Part 2110
Using Mirrors112
Small Items and Jewelry114
Fill Flash Outdoors115
Sunlight .117
Tungsten and Daylight Together118
Image Series121
Lighting Glass122

Final Words123
Glossary .124
Index .126

My aim in writing this book was to demystify and simplify many commercial photography lighting techniques. Inside these pages are a wide variety of lighting scenarios explained and diagrammed in a clear and detailed manner. They can be used by professionals and will give amateurs a leg up on the learning curve. I have used every one of the lighting techniques described herein on paying jobs, and each time, my client was pleased.

I have also provided strategies for designing a studio for the particular type of photography you do. You'll learn about the qualities of light and get tips for selecting essential photographic equipment. I will show you how to create studio sets inexpensively and how to stay within your client's budget. You'll also learn how to expand your client's budget and profit from creating better shots. You'll gain insight into selecting materials that will save you money, too.

You can also use this book to explain to clients the light you think will best enhance their project without having to set up the shot.

If you are interested in becoming a professional commercial photographer, this book will give you the inside scoop on how to do it. There are no silver linings or half-truths about the business. Photography has always been competitive and will stay that way forever. To get on top and succeed, you must not only know how to take great images, but you must operate your studio within certain business parameters. I wish there had been a book like this when I started out.

Working as a commercial photographer isn't always easy. For me, it has been a long and strenuous journey. The downfalls and victories along the way have inspired me to create this book and to show you how to become the best photographer you can be.

I now own Big Red Nose Productions, the fourth largest studio in Colorado and the largest studio in Boulder County. Our team of six averages one freelance photo job every six hours. We are published all over the world. We are producing movies, have our own international stock agency, and our own international talent database. We have also created an online photo school and have developed software for professional photographers. You too can achieve this level of success. Armed with the information in this book, you will be able to provide your clients with standout, evocative images that sell their merchandise in print ads and on the web.

Good luck.

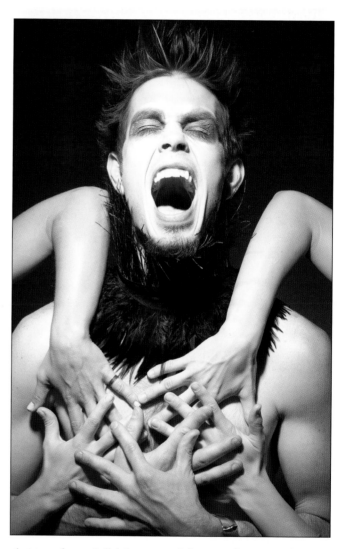

A strong, dramatic lighting concept is key to good commercial images. In the chapters that follow, we'll cover everything you need to know to photograph models and products in the studio or on location.

Part 1. The Foundations of Commercial Lighting

To create the most professional, provocative images possible, you must first learn some basics about working with light. In this section, you'll find chapters that cover lighting basics, including equipment selection, characteristics, and use. You'll also learn how to construct some useful setups and to read the numerous lighting diagrams in this book. Armed with this information, you'll be ready to delve into the creative aspects of commercial lighting.

1. Lighting Basics

Photography is 90 percent light and 10 percent subject matter. In order to create the best-possible results when photographing your subjects, you should have a general knowledge of light. Before investigating the equipment, diagrams, and other key foundational aspects of creating an effective image, we'll review the basics.

Types of Light

Light can either be natural or artificial. Natural light is light that comes from the sun, whether it's the low light that filters into a shady area, the light beams that filter through a window, or direct sunlight coming from a cloudless sky. Artificial light is light that comes from any other source. Photographers use both natural and artificial light of all kinds when creating images, and often these sources are used in combination to great effect.

Natural Light. Natural light can be used to create a variety of appealing effects, especially in portrait photography. While studio lighting offers the ultimate in control, many photographers prefer the simplicity of working with natural light.

Keep in mind that, because your light sources are fixed when using natural light, you will control the effects you achieve primarily by adjusting the position of your subject in relation to the light. You can also control the light by blocking it from above or the side (using a black card; see page 17) or by bouncing light into a shadow area (using a bounce card or another reflector; see page 17).

Overhead Light. When working with sunlight, it is best to avoid situations where the light strikes the subject from above. This can create unpleasant shadows on the face. This can be avoided by shooting early or late in the day, when the sun is naturally at a low angle (see page 8). Or, you can look

Effective lighting requires a solid knowledge of the characteristics and qualities of artificial and natural light.

for situations where the light is diffused and, if possible, blocked from overhead. The light at the edge of a clearing (with tall trees or branches overhead) is often ideal, as is the light on a porch.

Window Light. You can also use natural light indoors. Window light (or light through open doors) is often extremely flattering for portraits. Because windows tend to be large, the light is typically very soft. Windows, by their very nature, also produce light with good directional characteristics. If the light entering the window is too harsh, you can add a reflector on the shadow side of the subject to soften the shadows.

Golden Hour. When working outdoors, photographers often prefer to take advantage of the golden hour, a time when the sun is low in the sky and produces side and backlighting. The general rule is that the best light occurs from sunrise to one hour after sunrise and from one hour prior to sunset until sunset. Of course, light can be used throughout the day when the sky is overcast, the photographer is shooting in open shade, or the light is modified to produce softer light. When light is undiffused and directly overhead (e.g., midday sun), bright highlights and unflattering, hard shadows result.

Artificial Light. Artificial light options are characterized as instantaneous or continuous light sources. We'll take a look at instantaneous light options, then we'll move on to discuss continuous light sources.

Carefully controlled lighting is key to producing dramatic, attention-getting images.

Flash. Flash is useful when there is very little natural light or where the natural light needs to be enhanced. Many inexpensive cameras and some professional models have a built-in flash. This is either part of the camera assembly or it "pops up" when activated. Often referred to as "wink light" flashes, these units provide flash illumination on subjects that are fairly close to the camera (generally within 15 feet). These low-powered flash units do a very good job, but because the flash is so close to the camera lens, it is highly likely that you will get red-eye when taking pictures of people.

For better results, many photographers prefer to use on-camera flash. These are produced by camera manufacturers as well as third-party manufacturers like Metz and Quantum.

This type of flash is connected to the camera through the hot shoe or via a sync cord. The units can be mounted directly on the camera, held by the photographer at a position off the camera, or mounted above or to the side of the camera using a flash bracket.

These flash units may be completely manual or fully automatic. Manual flash units emit the same amount of light every time they are triggered. Some have a variable power control setting. A flash meter is helpful with these units so that you can accurately measure the light output and set your camera accordingly. In the automatic modes, the camera communicates with the flash and tells it how much light to emit for a proper exposure. This is accomplished using TTL (through the lens) metering technology.

Strobes. Studio strobe lights (also called electronic studio flashes) are the favored light source for most studio photographers. They run cool, are

portable, and pair easily with daylight film (or the daylight white balance setting). There are two types of studio strobes: monolights and power packs. With either type, your camera communicates with the light units via a sync cord or slave unit (this will be discussed in more detail below).

A monolight is a self-contained light that has both the power supply and the flash head built into one complete unit. Monolights are AC powered and can usually be triggered by direct connection to the camera's flash sync, or via a slave unit that allows the strobe to be triggered remotely (i.e., without a direct physical connection to the camera). Many monolights have a built-in slave unit that will fire the flash automatically when another strobe is triggered in the studio. Separate radio slave units such as the Pocket Wizard or Quantum radio slaves can also be connected to the monolight and the camera to trigger the light.

Power pack lighting units can accept multiple flash heads, which can be independently adjusted. Studio power pack units can be either AC or DC powered. Some units will also operate on DC voltage with a car battery. This can be handy on location when you want the flexibility of a studio light system but cannot plug into an AC power source.

When triggered by the camera's shutter button, strobes emit a "pop" of light. Obviously, working with only this momentary burst of light would make it very difficult to place your lights in relation to the subject. Therefore, strobe units also house a modeling light, typically a 250-watt tungsten halogen bulb. This light stays on continuously to help you focus your light and see how it illuminates your subject. (Some modeling lights turn off after the strobe is fired then turn on again when the flash has recycled and is ready for use in the next shot.)

Now that you have an understanding of the available instantaneous light sources, we'll take a look at your continuous light source options.

Before the invention of strobe lighting, continuous light sources were the only option for studio photographers. Today they are experiencing a renewed popularity. Continuous sources have one main advantage over instantaneous ones: you see exactly the lighting effect you will get, because the light source is both the modeling light and the actual shooting light. There is also more light available for focusing with these sources. Additionally, since the advent of digital imaging, balancing your recording medium to the color temperature of these lights is very simple (simply set your camera's white balance appropriately, using a custom setting if needed).

Overhead lighting—whether natural or artificial in origin—is pleasing to most viewers.

Tungsten Lights. Tungsten lights for photography are like supercharged versions of regular household lights. They are available from 100 watts all the way up to 24,000 watts. Shooting with these lights requires adjusting

your camera's white balance setting to tungsten, or using a tungsten-balanced film.

HMI Lights (Halide Metal Iodide). HMIs take a short time to warm up and require a ballast. However, they are very bright and daylight balanced. These units tend to be very expensive.

Fluorescents. Professional photographic fluorescents, unlike tungsten lights, run very cool, which can help keep your subject more comfortable. They can be either daylight or tungsten balanced but tend to be limited in the intensity of their illumination.

Characteristics of Light

Light is described according to the effect it has on a subject or scene. The descriptions that follow apply to both natural and artificial light.

Color Temperature. The light that we see is comprised of seven distinct colors: red, orange, yellow, green, blue, indigo, and violet. The human eye does a good job of balancing these colors, so colors look the same to us whether they are under reddish light (like at sunset), yellowish light (like a household lamp), or greenish light (like most fluorescents). Film and digital image sensors, on the other hand, do not adapt as readily.

Therefore, it is important to evaluate the color of the light before shooting to ensure accurate color results. The color of a light source is described as its color temperature.

"White" light is the starting point for color temperature and measures about 5500 degrees Kelvin (5500K). Therefore, daylight film is balanced to precisely this color temperature. As the sun rises or sets, the color of its light gets warmer, which is noted as a lower temperature (as unintuitive as that may be!). Temperatures higher than 5500K indicate a light balance that is cooler, or more blue.

When the color balance of the medium used to capture the image matches the color temperature of the light, the colors in the image will be rendered as the eye sees them.

Direction. One of the most important qualities of the light from any given source is its direction. This determines where highlights and shadows, the tonalities that produce the look of a third dimension in photography, will be created on the subject. As you will see, the direction of light is usually described in relation to the subject, so moving either the light source or the subject can result in a change in the direction of the light. By changing the camera's perspective, you may also include more or less of the shadows and highlights created by the light.

In most cases, a light source illuminates the side of the subject closest to it and leaves its opposite side in shadow. When extremely diffuse light is used, however, the scene sometimes lacks shadow.

Light coming from in front of the subject is called front lighting. With this type of lighting, the detail in the front of the subject is well illuminat-

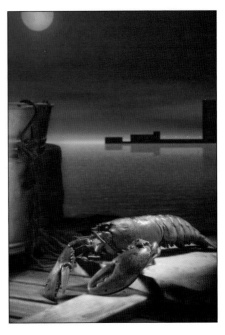

It's important to evaluate the color of light in the scene before shooting to ensure the desired color rendition in your images.

Light Temperatures

match flame 1700–1800K
candle flame 1850–1930K
sun (at sunrise or sunset) 2000–3000K
household tungsten bulbs 2500–2900K
tungsten lamp (500W–1000W) 3000K
quartz lights 3200–3500K
fluorescent lights 3200–7500K
sun direct at noon 5000–5400K
daylight 5500–6500K
overcast sky 6000–7500K
computer monitor 6500K
outdoor shade 7000–8000K
partly cloudy sky 8000–10,000K

ed. As there may be only minimal shadow areas, however, the image may lack dimensionality and texture. This type of lighting is frequently used in fashion and glamour portraiture because it creates smooth, flawless-looking skin.

Backlighting is light that comes from behind the subject and toward the camera. This type of light often leaves the front of your subject in shadow or underexposed in the final image. It can also cause the edges of a subject to appear lit (or even to seem to glow). When this effect occurs with back-lighting, it is often called rim lighting.

Side lighting, as you might suspect, originates at some angle to the left or right of the subject. This type of lighting can result in more pronounced shadows. As a result, it is common in portrait photography, where showing the shape of the subject's face is important to the image.

Hard Light vs. Soft Light. While the direction of the light determines where on a subject the highlights and shadows will fall, the quality of the light will determine how soft or well defined these shadows are. Based on this, light is described as either hard or soft. Hard light, like the light available outdoors on a bright, sunny day, produces dark, hard-edged shadows, bright colors, and bright highlights. Soft light, like that from an overcast sky, produces paler, softer shadows, or no shadows at all. The colors of objects illuminated with soft light also tend to be more subdued, or muted. For most images, soft light is the photographic ideal. While soft light is not always readily available in a given scene, hard light can be modified and made softer through the use of light modifiers. This will be covered later in this chapter.

Whether a light source is soft or hard is determined by the size of the light in relation to the subject.

Hard light is produced by sources that are small in relation to the subject. For example, think of the crisp, well-defined shadows that appear on a bright, sunny day. Of course, the sun is an immense source of light, but because it is so far away, that one tiny dot of light in the sky is actually very small in relation to the subjects it illuminates here on Earth.

Soft light is produced by sources that are large in relation to the subject. Taking the example of the sun again, imagine that you are standing outside on a very overcast day. If you can see your shadow at all, it will be very pale and not very well defined (i.e., the edges will be soft and fuzzy). This is because the clouds overhead have broken up the light and scattered it across the sky. On a day like this, the entire sky is the light source—and it's huge! As a result, the light is soft.

When we consider artificial light, the same principles apply. If you light your subject with a relatively small source (say, a bare bulb) from a distance, the light will be hard. If you move that bulb closer to the subject, the light will become softer. You can also soften the light by adding something between the source and the subject to diffuse the light. This could be a pro-

Soft light is produced by sources that are large in relation to the subject.

fessional light modifier (like a panel) or something as simple as a large white sheet held up between the subject and the light.

Conversely, if you are using a large light source (say, a large window) but don't see the crisp shadows you want, you could move your subject farther from it. This will make the light harder.

The distance between your subject and the light source will also have an effect on the strength of the highlights and shadows in your image.

Exposure

When you take a picture, getting deep, saturated black tones with detail, bright whites with detail, and good, accurate color is important. If an image is overexposed (your camera lets in too much light), the image may be washed out and the highlights (the brightest areas of the scene) will lack detail. When there is not enough light striking the film or image sensor, the image will be underexposed and the shadow areas (darkest parts of the scene) will lack detail.

Getting deep, saturated blacks, bright whites with detail, and good, accurate color is only possible with a careful exposure.

There are three main factors that determine the amount of light that is used to create the image, and whether your exposure will be acceptable. The first factor is the film speed/exposure rating. Below, we'll look at how your aperture and shutter speed selection will affect your image.

Aperture. The aperture you select determines the depth of field in your image. It is also important to note that the aperture you choose determines the amount of light that is allowed to strike the film/sensor. Therefore, the aperture setting also has an affect on the overall exposure of the image. The smaller the aperture, the less light reaches the film. The larger the aperture, the more light reaches the film. To "open up" is to increase the size of the lens aperture. It is the opposite of "stopping down."

With each full-stop change in the aperture, the amount of light striking the film/sensor is either doubled or halved. It may be helpful to review the chart below to better understand the relationship between the aperture size and the amount of light used to make the exposure.

f/2.8—Twice as much light as f/4
f/4—Half as much light as f/2.8, twice as much light as f/5.6
f/5.6—Half as much light as f/4, twice as much light as f/8
f/8—Half as much light as f/5.6, twice as much light as f/11
f/11—Half as much light as f/8, twice as much light as f/16
f/16—Half as much light as f/11, twice as much light as f/22
f/22—Half as much light as f/16

Shutter Speed. The shutter speed refers to the amount of time that the camera's shutter remains open, allowing light to strike the film/sensor. The shutter speed is usually rated in fractions of a second, though photographers sometimes use long exposures to photograph in low-light situations.

The slower the shutter speed, the greater the amount of light that reaches the film. The faster the shutter speed, the less the amount of light that reaches the film. Each full-stop change in the shutter speed means that the amount of light striking the film/sensor is doubled or halved.

Fast shutter speeds are typically used to control exposure in brightly lit situations or to freeze moving subjects. Faster shutter speeds also help to alleviate the effects of camera shake, a blurring that sometimes occurs due to camera movement when handholding the camera.

Long shutter speeds are used to allow more light into the camera in low-light situations. They can also be used to blur moving subjects, accentuating the motion as a blur across the frame. When using long shutter speeds, there is an increased risk of blurring due to camera movement. Therefore, the camera should usually be tripod-mounted or otherwise stabilized. You may even wish to use a cable release or remote to trip the shutter without touching the camera (and potentially moving it).

To further increase picture sharpness, a photographer can lock up the camera's mirror. In most SLR cameras, the photographer sees the scene through a viewfinder and mirror that allows you to see through the lens. When the shutter is triggered, the mirror flips up and out of the way to allow light to reach the film or the sensor. The movement of the mirror can cause some camera shake, which can result in an image that is less sharp.

Using a light meter or a histogram will help you to ensure that your exposures are where you want them before you wrap up a session.

Light Meters. A light meter is a device that measures the light falling on a scene/subject or reflected by a scene/subject. Based on this measurement, the meter recommends a particular aperture, shutter speed, and ISO/exposure rating combination that will produce a well-exposed image. There are two basic types of meters for photography: reflected light meters and incident light meters.

Reflected Light Meters. All meters that are built into cameras and some handheld meters are reflected light meters. The photographer points the light-measuring portion of the meter (usually a dome on handheld meters) at the subject and measures the amount of light that is reflected from the subject.

Because this type of meter measures the light reflected from the subject, the tone and color of the area you target with the camera's meter will determine the exposure settings it provides. For example, when a camera meter targets a white area of the subject, it will determine you need less exposure than if it targets a black area of the subject.

To combat this, more advanced digital cameras measure multiple areas of the scene to provide an accurate average reading. If your camera does not offer this option, you can also improve your reflected light metering results by using a gray card. These cards, available from any photography supply store, are a solid, medium gray tone. When you place this card in the same light as your subject and meter off the card (rather than the subject; this is called a gray balance reading), you can be assured of a proper reading.

Most reflected light meters have an angle of view of about 50 degrees, similar to a normal lens. A spot meter, however, is a reflected light meter that has a much smaller angle of view. This provides an accurate measurement of a particular spot in the scene (for example, your subject's skin tone). Some spot meters can have as little as a 1-degree angle of view.

Incident Light Meters. Another type of meter is an incident light meter. Incident light meters measure the light falling onto the subject, so they provide an accurate reading regardless of the color or tonality of the subject. An incident light meter is held at the subject position and pointed back toward the camera. Incident light meters have a very wide angle of view, up to 180 degrees.

Other Options. Many popular handheld meters have reflected, incident, and spot metering capabilities. These meters give the photographer the most flexibility to make the right metering choice depending on the subject and photographic conditions.

Some meters display an exposure value (EV) reading, which provides a choice of compatible shutter speeds and aperture settings. This allows the photographer to choose the appropriate settings depending on the subject being photographed and how much depth of field is desired in the photograph. For a fast moving subject, the photographer would want the fastest shutter speed in order to freeze the motion. This fast shutter speed would require a corresponding large lens opening to allow more light. However, if the photographer was working with a family group consisting of several people in rows, he would want a smaller lens opening for maximum depth of field. This small lens opening would require a slower shutter speed to allow more light to be recorded.

A flash meter is another common type of meter. This measures the light output from a portable flash unit or studio strobe light. An essential tool in the studio, a flash meter allows the photographer to measure each light individually and create the desired light ratio on the subject.

A color temperature meter (or color meter) measures the color temperature of the light in a scene. This is used frequently by commercial photographers to ensure that the colors in their images will be properly recorded.

Histograms

Rather than rely on either of the light meters discussed in this chapter, I use the histogram in my camera or digital imaging software to make sure that my exposures are right on the mark. For me, this method is more accurate—and commercial work demands perfect exposures every time. The text on meters, therefore, is provided solely for informational purposes, and may be useful for some photographers.

2. Equipment

The equipment you need for a session will vary from job to job. However, it's a good idea to have a solid understanding of the tools that are available to you. In this chapter, we'll take a look at some of the tools that many commercial photographers rely on when working on assignment.

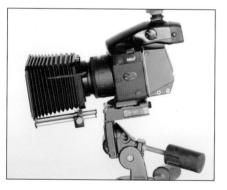

New camera models are constantly being introduced. Do some careful research to ensure that any model you're considering offers the features you want. There are no hard-and-fast rules in selecting a professional camera. Much of the decision-making process boils down to your personal preferences.

Cameras

Cameras come in a wide variety of makes and models. There is no single camera that is better than all the rest. Consider digital versus film, file sizes, shots per second, storage media, transfer rates, lens clarity, ergonomics, and lens sets. You should not buy a camera without looking at all these variables. You must also determine whether the camera suits your shooting style, workflow, and budget. A professional camera can cost anywhere from $5000 to $50,000.

Electronic Flash Units

Your lights are the second most important tool. Flash is the lighting unit of choice for most studio photographers. These lights run cool, are portable, and pair easily with daylight film or your digital camera's daylight white balance or gray balance setting.

Power Packs. Power packs can power multiple strobes, which can be independently adjusted. These can be AC or DC powered. Some will even operate on DC voltage with a car battery; this is a great option for location photographers who cannot plug in to an AC power source.

You want to make sure that the packs you buy are extremely durable. As you can see in this photo, power packs get used hard and are always on the floor of the set.

Modifiers that Attach to Flash Units

Reflectors. Dish-type reflectors are an important part of your lighting kit. Without reflectors, your lights can be easily broken. A broken strobe is expensive to fix. Your reflectors also cast a certain type of light that is needed for fills, highlights, and the feeling of direct sunlight on your subject. As a general rule, the more expensive your lights, the more expensive your reflectors will be. You should have a reflector for every strobe you own.

There are a number of modifiers designed for use with a reflector dish, including snoots, barndoors, and honeycomb grids. I use only the honeycomb grids.

Honeycomb Grids. A honeycomb grid is a light modifier that typically fits inside the reflector dish and forces the light to travel in a straight line. These devices allow you to create precise lighting effects. The most popular types are the 10-, 20-, 30-, and 40-degree grids, but some manufacturers offer an ultraprecise 5-degree honeycomb grid.

Softboxes. A softbox is a large fabric housing for your light source. Softboxes come in wide variety of shapes, sizes, and depths. Check with your retailer to identify the best soft-

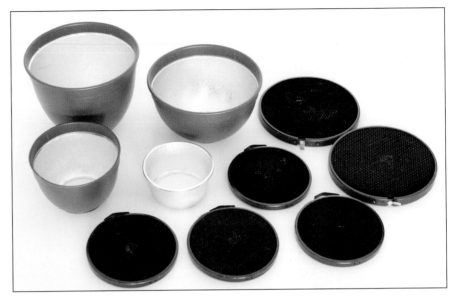

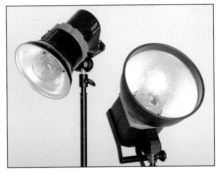

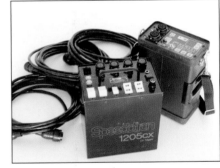

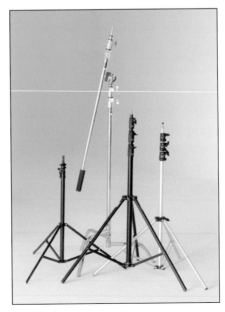

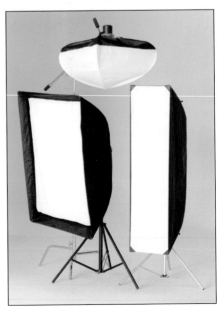

*Top—Dish (parabolic) reflectors and honeycomb grids can be used to direct the light from your strobes. **Center left**—Strobe lights are at the heart of every photographer's lighting kit. **Center right**—A power pack can be used to power multiple strobes. **Bottom left**—A heavy-duty stand is an essential part of your tool kit. In my studio, we use silver stands to hold our lights and black stands to hold up bounce cards, backdrops, etc. **Bottom right**—A softbox is a fabric housing that is used to diffuse the light produced by a strobe. As this image illustrates, softboxes come in a variety of shapes and sizes.*

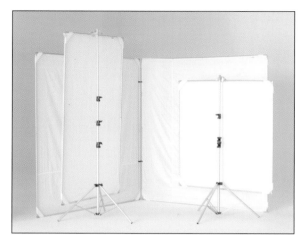

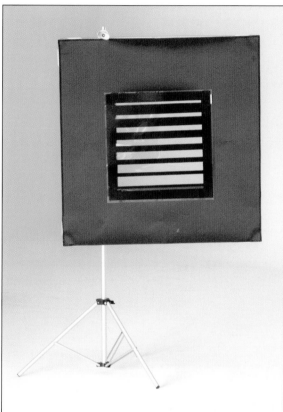

Top—Light panels are used in most of the lighting scenarios that appear in this book. They're light weight and offer a more versatile, precise approach than do softboxes. Bottom—By using a cookie, you can cast interesting patterns of light and shadow on your subject or scene.

box for your projects. Be prepared to spend a little more for a good softbox. Price makes a huge difference in the quality of light that is cast.

Umbrellas. This umbrella-shaped modifier is clipped or mounted onto a strobe to diffuse and soften the light falling on a subject or set. These modifiers are available with a silver lining for cooler light, gold for warmer tones, or a white interior, which creates a higher level of diffusion but does not impact the color of the light produced.

Stands

The stands you choose should be sturdy and must be able to support the weight of your lights or freestanding modifiers (see below). Never use a questionable stand. If someone gets hurt, it could easily be the end of your photographic career.

Stands come in two colors, black and silver. I use black stands to hold up sets, set poles, bounce cards, etc., and use silver stands to hold the lights. This makes it easy for me to communicate the stand function to any assistants who are new to the studio and my way of working.

Freestanding Modifiers

Panels. This white translucent fabric panel with a steel frame (about 4x4 feet) is a necessary part of your lighting kit. By shining a strobe through it, you can produce a nice, soft light source. Also, the strobe can be positioned at various points along its surface. This is a clear advantage over using a softbox, in which the light is in a fixed position inside the fabric housing. Using panels allows you to create more precise, professional lighting effects.

The Chimera light panels are large and durable but compact enough to be placed around a tabletop set. The strobes seem to snug right up to the panels. The steel frame is the best in the business and is built to last a lifetime. In addition to serving as shoot-through panels, they can also be used as bounce panels and to block unwanted light from hitting the set. You can also use them to create mobile dressing rooms and small site tents to keep a crew safe from the elements.

Bounce Cards. A bounce card is a white card that is used to bounce light back into the set from another light source. In my studio, we use artist's canvas, painted white, or foam core.

Black Cards. A black card is panel that is placed between a light source and the subject to block light from hitting the subject or set. You can use black foam core as a black card or can purchase one from a photo retailer. The term is synonymous with gobo.

Cookies. If you have an expanse of evenly lit background (for instance, in a room shot), you may want to employ a cookie to break up the background by introducing shadow patterns. Essentially, a cookie is a solid panel with holes of random or uniform shapes cut into it. When light shines through it, a cookie can create the effect of the shadows of leaves, a window pane, or just an abstract, dappled light effect.

Cookies can be purchased from a photo equipment retailer, or you can make your own from black foam core.

Mirrors. Mirrors are a key tool in the creation of a well-lit photograph. You can add light directly to areas that need light without affecting the overall shot. Keep an array of sizes and shapes on hand; they are inexpensive tools that can help you achieve effective, well-lit images.

Facing page—As a commercial photographer, you'll find that each subject and location requires you to come up with a unique lighting setup. The images here show you a few of the lighting setups I've used for some of my own work. You'll recognize in these images several of the tools I've discussed throughout this chapter.

Equipment Used to Make this Book

Below is a list of the equipment used for day-to-day operations in my studio. This is the same equipment used to make this book.

Think before you buy. Photo gear is expensive. I have not been paid to endorse any of the following items. My selection and recommendations are based upon years of experience with a wide array of gear.

Cameras
Mamiya 645AF body
Phase One H5 digital back
Olympus E500
Canon D1
Canon E0S 630
80mm lens
35mm lens
14–45mm lens
40–150mm lens

Camera Stands
Foba Asaba
Triton field tripod
six 11-foot Bogen stands (B0336)

Lights
three Speedotron 1205cx light kits
six Speedotron lights
two Hensel Porty 1200 battery packs
four Hensel lights

Light Stands and Clamps
six small black Speedotron kit stands
six TCI clamps
eight super clamps
two Avenger boom (C) stands
two Avenger boom arms
Orange stand weights (15 pounds)

Softboxes
medium Chimera
two thin vertical softboxes
square Plume
round Plume

Panels
two 6x6-foot Chimera light panels
four 4x4-foot Chimera light panels
two 8x4-foot Lightform light panels

Computers
two Mac G5s (video editing and
 Photoshop retouching)
three E-Macs (support and photographer's
 offices)
two Mini Macs (sales and billing)
12-inch iBook 600MHz DVD/CD/RW
20GB hard drive
14-inch iBook 1.33GHz DVD/CD/RW
40GB hard drive
seven 300G Maxtor FireWire drives (for
 media backup)

Cables/Syncs
four sync cords
eight FireWire cords
Pocket Wizard
two optical slaves

Printers
HP 20ps
Epson printer
two Canon printers
Epson matte photo printer paper

Office Machines
fax machine
copier
Pitney Bowes stamp machine

Workshop Tools
table saw
chop saw
two cordless drills
hacksaw
circular saw
brushes, paint rollers, and trays
various screwdrivers
tin snips
ratchets
four sawhorses

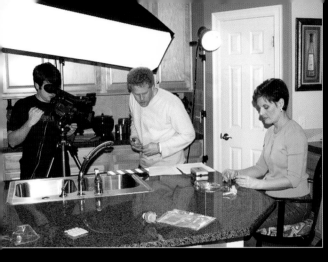
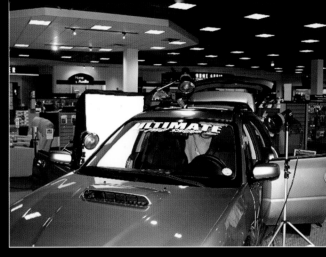
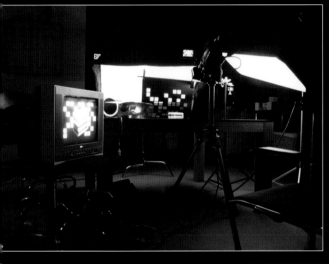

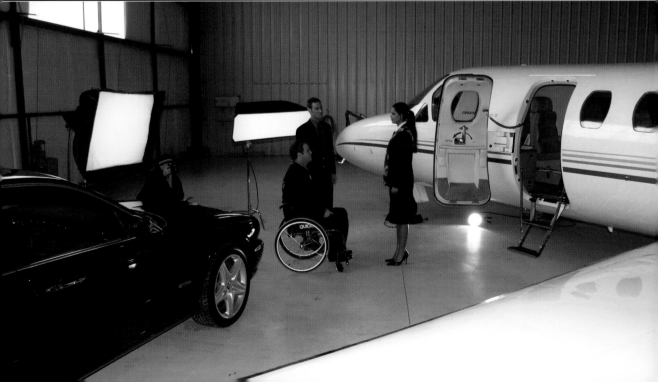

3. Understanding the Diagrams

This book is filled with diagrams that will help you to easily produce a variety of commercial lighting styles and show products—and models—to best effect. Though the diagrams are clearly marked and easy to understand, a written overview of each illustration fully explains each light's placement in the illustration, and photographs show the result that each lighting setup achieved. This three-pronged approach will ensure that you can easily achieve the look you are going for. It will help you to develop your own instinctive style of lighting, to solve problems, and succeed. The final outcome should be an excellent understanding of light placement with a sense of your own style.

The previous chapter outlines all of the tools used to create the images in this book. Using these tools will help you take your lighting to the next level.

This diagram is labeled with the five positions at which the strobe may be placed to shoot through the light panel.

An Overview

The three squares below show the way light shines through a panel. The reference positions from left to right are P2 (upper-left position), P5 (lower-left position), and P1 (center position). As the light shines through the panel, it disperses evenly from the center of the strobe light. This allows the photographer to enhance nuances in a shot.

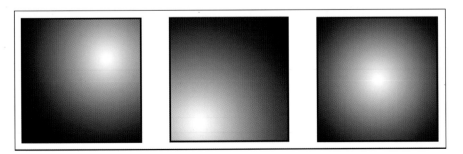

This trio of images shows the changing effect of moving a strobe's position behind a light panel.

Using a panel provides photographers with more control than does using a softbox. While the position of the light can be changed relative to the panel, the light in a softbox is continually in the center, or the P1 position. In the image below (top), you'll see that the position of the strobe stays the same, but the panel is repositioned. Turning a panel affects the way light shines through it.

With the panel perfectly horizontal (center of the diagram), a large, flat light source is produced. As the panel is turned, the light refracts differently off of the subject and an increasingly thinner, longer light source is produced. The changing appearance of the light is dramatic and highly visible.

This diagram below (bottom) shows how changing the position of the strobe affects the way the light shines through a panel. As you turn the light head, the light will refract differently off of your subject and produce a gradation of light on the set or subject. This is a great way to control glare on your subject.

These illustrations show the versatile lighting approaches that can be achieved by rotating the light panels (top) or rotating the strobe head (bottom).

In this book, you will find detailed diagrams that can be used to light rooms, highlight the styling of an automobile, shoot smaller products, portraits, and more. We'll look at some ideas for creating an effective setup for your session in the next chapter.

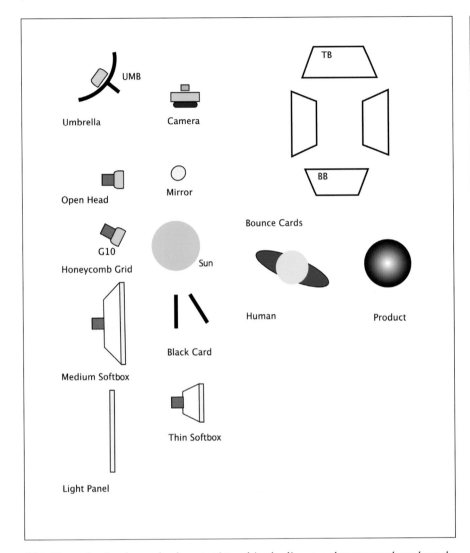

Lighting Shorthand

Below you will find a list of the abbreviations used in the diagrams to designate the various tools. Refer to this list, if need be, as you try your hand at creating the lighting setups in your own work. You may use the diagrams to show prospective clients—or clients you have an existing relationship with—your lighting ideas, giving them a better sense of what you aim to create.

BB—bottom bounce card
TB—top bounce card
SB—side bounce card
G10—10-degree honeycomb grid
G20—20-degree honeycomb grid
G30—30-degree honeycomb grid
G40—40-degree honeycomb grid
CB—ceiling bounce light
MR—mirror
OH—overhead light
P1—strobe is positioned in the center of the light panel
P2—strobe is positioned in the upper-left corner of the light panel
P3—strobe is positioned in the bottom-left corner of the light panel
P4—strobe is positioned in the upper-right corner of the light panel
P5—strobe is positioned in the lower-right corner of the light panel
UMB—umbrella

This illustration is a key to the elements pictured in the diagrams that appear throughout the book.

4. Studio Setup

When you design your studio, keep in mind that you are designing a workspace. You will need a place for your clients to relax and feel comfortable and a private place where you can keep your records and do your behind-the-scenes work. You will also need a client-friendly place for your customers to view and order images, some clean restrooms, and some type of storage area. A clean, well-planned, and efficient studio space shows your client that you care and that you are a professional. A dirty, poorly planned, and sloppy workspace tells the client to look for a new photographer.

How to Create a Simple Product Table

In any photographic studio, small- to medium-size products are most often photographed on a small tabletop crafted using two sawhorses topped with a 4x4-foot board (this setup can hold up to 200 pounds). Two small stands are placed behind the tabletop, and the backdrop pole rests upon the stands. Rather than using backdrop paper, you can also use Formica, which comes in a handy 4-foot width. In this case, simply use the clamps to secure the backdrop to the stands and drape it across the table. The set is fast and easy to assemble and disassemble. All the pieces can be stored easily, and the set components can be used in the creation of many other sets.

Another nice thing about this type of setup is its versatility. You can choose from a wide variety of backdrop colors and textures. You can create useful setups and control your background falloff easily. By using a metal or glass table topper and placing the backdrop a foot or two away from the set, you can create simple, classic product photos.

I realize that there are many expensive alternatives to the product table, but the one shown here costs about $50.00 to make (the sawhorses are the

Tools for a Simple Product Table

two sawhorses
one 4x4-foot flat board
two small stands
backdrop pole
4x8-foot sheet of Formica
three small A-clamps
two super clamps

most expensive parts) and allows you to photograph a wide variety of products efficiently. I've produced entire catalogs using this setup.

Tip: When your client arrives for a simple product shot, have the set up and ready to go. Have a simple lighting plan in place and a chair for the client to sit in. This immediately makes the client feel welcome.

Larger Sets

Many shots require larger, more elaborate sets. When creating a larger set, make sure it is sturdy and will hold the amount or size of products you will photograph. Trust me, when you have a lot of products on set, the last thing you want is to have your set fall apart or get bumped while you're putting the finishing touches on your composition. I have seen poorly designed scenes bring otherwise successful projects to an immediate halt.

You must also ensure that you and your client can reach into the set to arrange the props and objects to be photographed. You can fill these spaces in later with the lights used on the shot, but get the shot set up first.

Here is an image of a tabletop set that I often use in my studio.

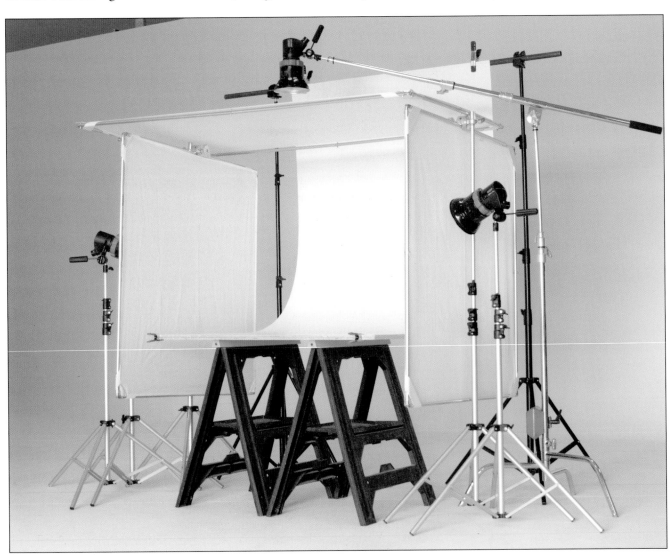

Tools for a Larger Product Setup

four sawhorses
two hollow doors
two large stands
backdrop pole
large paper backdrop
three medium A-clamps
two super clamps

This diagram shows the elements required for a large product setup.

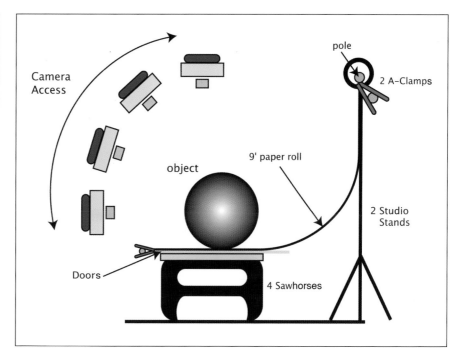

Camera Access

object

pole

2 A–Clamps

9' paper roll

2 Studio Stands

Doors

4 Sawhorses

To build a larger product set, follow the basic steps outlined above using four sawhorses and the two hollow doors rather than the 4x4-foot board. The doors used do not have the knob hole drilled. You can get these doors at any hardware store for as little as $35.00 each. These doors are great for this because they are lightweight but strong, do not warp, and are ready to paint. Of course, you'll need a larger backdrop pole, larger stands, and the paper of your choice.

Once you have this setup, you can expand the set. This set is safe, predictable, and inexpensive. It can also be quickly assembled and disassembled. As with the smaller set, it can be stored easily when space is limited.

Tips: Obtain a detailed list from the client on the shot's contents and props. The list should entail what the client expects from the shot, what products will be in the shot, and the proposed composition. For large sets and complicated propping, you may need to hire a stylist to help you with the project.

Room Sets

The next size up from here is the full backdrop set, or room set. These sets usually consist of a large backdrop such as coved walls to create a room feel, and props for the building of an entire room. Sometimes these sets need to be set up and painted days in advance. With careful planning and communication with the clients about their specific needs, you should be able to have the set ready when they arrive for the shoot.

These sets must be user-friendly. There are usually models in the shots. The photo team may also need to access the set to adjust one thing or another. When this is the case, you must make sure that nothing in the set can fall and injure someone. Make sure that all the cables are taped down

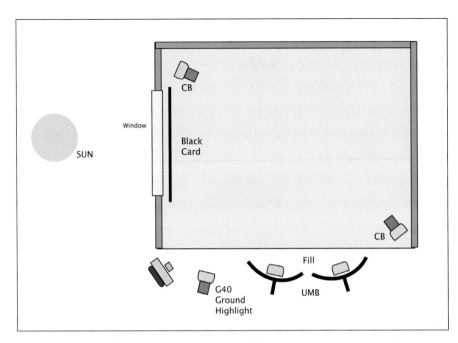

Tools for a Room Set

8-foot or taller light stands
umbrellas
honeycomb grids
tripod
large black cards
large bounce cards
cleansers

This diagram shows a setup that can be used to effectively light a room shot.

and that all the booms and stands are fully secured with counterbalancing weights. Also make sure that any artificial walls are clamped and will not fall. I cannot emphasize this enough. If something falls and hurts someone, it's the photographer's fault, not the assistant's, and never the client's.

The above diagram shows the placement of unmodified strobes, strobes fitted with honeycomb grids, umbrellas, the camera, black cards, and the sun in a room shot. Note that I have not provided the lights' power settings or the specs for other equipment. These diagrams are intended only to show you how to position the lights; the other creative aspects are up to you.

Reflective Sets

When placed on two sawhorses, a 4x4-foot piece of $^3/_8$-inch tempered glass can make a simple, clean, and effective tabletop. You can place the product on the glass and add a piece of foam core underneath the glass to enhance its reflective qualities.

You can also go without the foam core and place a backdrop of the client's choice underneath the glass or lay the backdrop upon an angled piece of foam core.

Glass is highly reflective. Keep in mind that any light from above the glass will reflect off of its surface. To eliminate the possible reflections, you can light your objects from the sides. The reflection from the product is not a bad thing, however; you can use it to make very attractive shapes that enhance the overall image. If you are using an overhead light, bring it in from the back overhead area of the set, then use bounce cards at the front of the set to add light to the front of the products.

Placing a light under the set helps create separation between the glass, the product, and the backdrop. You can increase the brightness of this light to create a surreal illumination on the subject. Alternatively, you can decrease

Tools for a Reflective Product Set

two sawhorses
4x4-foot tempered glass ($^3/_8$-inch thick)
two large stands
four small stands (for lights and panels)
foam core
canned air
glass cleaner

This diagram shows how you can effectively create a floor shot using many of the same materials used in the previous sample setups.

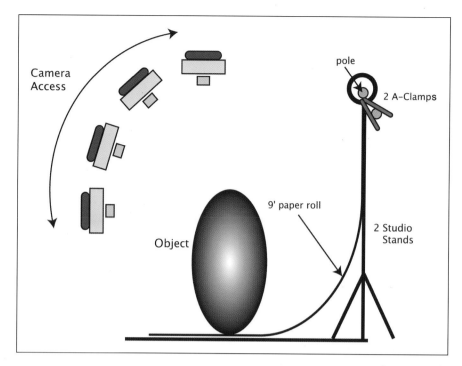

Tools for Inexpensive Sets		
sheet metal	old boards	carpet remnants
doors	computer parts	canvas
paint	wire	bricks
wallboard	cable	tiles
handmade paper	dirt	Formica
painted foam core	sand	acrylic
chrome pipe	grass	glass
brass pipes	rocks	
old tires	gravel	

this light to create a gloomy reflective surface. For shadow-free shots, you can replace the glass with frosted acrylic.

Creating Inexpensive Sets

When creating a set, think about your client's budget. Careful planning can save your clients money, and if you save your client money, they will be back.

There are many ways to create low-cost sets. One simple way to do this is to plan out the shot prior to execution. Doing this allows you and the client to understand exactly what is needed to make the final set. While you are going over the job with your client, you can suggest materials you already have on site to use as backgrounds.

Lighting scenarios that enhance the overall photo should also be presented to your client at this time. Many times the client is looking for a little drama in the background that can be created with the proper shadows and highlights. If you are building a large set, remember that the main purpose of the photograph is to enhance the person or product. If you keep this in mind, you will have no problem earning the client's business in the future.

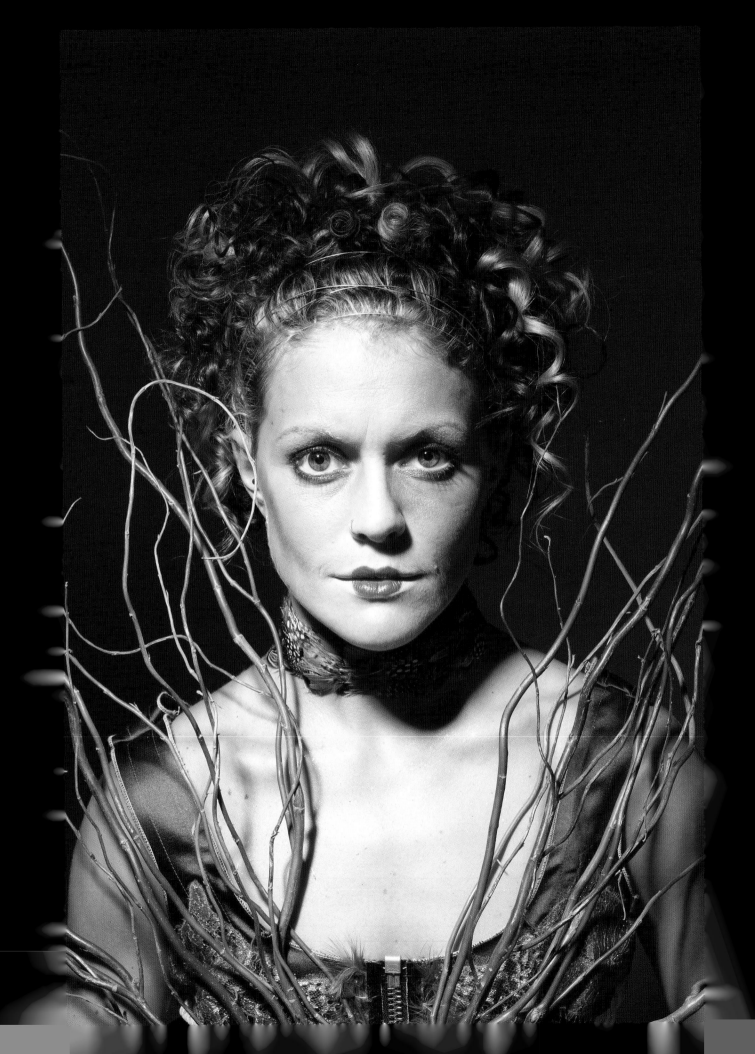

Part 2.
Using Lights and Modifiers

In commercial photography, creating precise, powerful lighting on your product or model is essential. In this section, you'll learn how to use light panels, honeycomb grids, umbrellas, and softboxes to produce the most evocative, expressive images possible.

5. Panels

The softbox has been a standard lighting tool in photographic studios for years. The light produced from a softbox is diffuse and is pleasing to the eye. The only drawback to most softboxes is that the light always has to be in the center of the softbox. This means that to adjust the light even slightly, you must move the entire softbox.

By using a light panel (a large white translucent fabric panel with a steel frame) to diffuse your light, you can produce the diffused lighting effect of a softbox but ensure better control. When using panels, you can position the strobes anywhere you wish behind the panel's surface. Conversely, you can

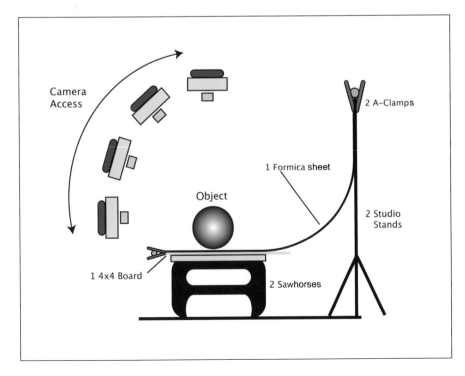

This simple setup was used to photograph the volleyball pictured throughout this chapter.

keep the strobe in a static position and move the panel. You can also place black paper over the panel to manipulate the light hitting your subjects.

Light panels can be set up quickly, stored in small spaces, and can be used as sun tents or dressing rooms while on location. Also, the time spent on lighting will decrease. Light panels are a favorite tool at my studio. Accordingly, they play a big part in the lighting scenarios presented in this book.

The diagram on the facing page shows a side view of a tabletop setup used to photograph a volleyball. Two plastic sawhorses are topped with a 4x4-foot board, secured with an A-clamp. A sheet of Formica is used as the backdrop. Two A-clamps are used to secure the backdrop to two studio stands placed behind the set.

The ball (represented by a gray sphere) is placed on the tabletop. The camera is positioned at the front of the set. The camera illustrations show the variety of shooting angles that are available once the set is created.

All tabletop setups in this book are built using this technique.

The panel is on the right side, parallel to the set. The strobe is in the center of the panel, or the P1 position. In this image and throughout the series, the strobe is on full power, and the camera is in a fixed position on a studio stand.

The ball has a defined bright side and a defined dark side. You can see detail on the surface. There is a dark shadow where the ball meets the tabletop, creating a defined area of contact. This creates a feeling of depth and dimension.

All of the volleyball images in this chapter were shot by Justin LeVett.

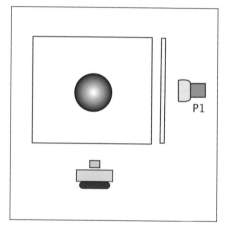

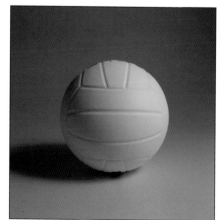

The panel is on the right side, parallel to the set. The strobe is in the upper-left corner of the panel, or the P2 position. In conjunction with other lights, this is a great fill light.

With the strobe positioned at the top of the panel, the illumination is dispersed downward. There is detail in the ribs of the ball and a shadow at the table contact point. However, more light is cast on the set and the volleyball, and the apparent dimension is minimized.

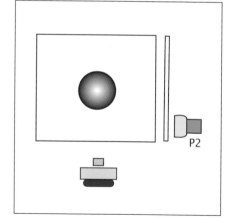

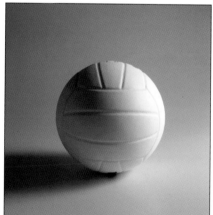

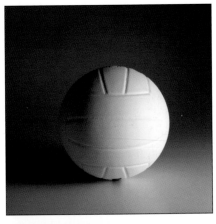

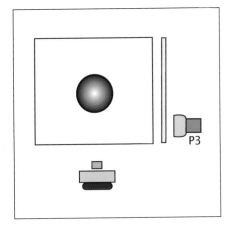

The panel is on the right side, parallel to the set. The strobe is in the bottom-left corner of the panel, or the P3 position. If softened, this would be a great place to start off a main lighting position.

In this image, the ball's dimension and depth are enhanced. With the light coming from the bottom of the panel, it disperses upward. More light is cast off the set, and less light hits the ball. There is less detail in the ribs of the ball on one side and a shadow at the table contact point. The back of the set appears darker.

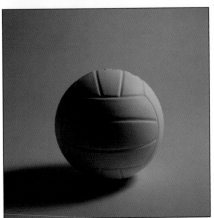

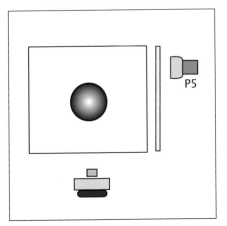

The panel is on the right side, parallel to the set. The strobe is in the top-right corner of the panel, or the P4 position. Most of the light is going off the set and over the product. In conjunction with other lights, this is an optimal fill light.

The ball's dimension and depth have softened. With the light coming from the back of the set, the back of the ball is illuminated. The white Formica backdrop acts as a bounce card, filling in the areas of the ball that we can see. The contact point shadow is still strong but has moved forward.

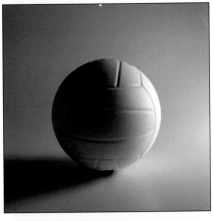

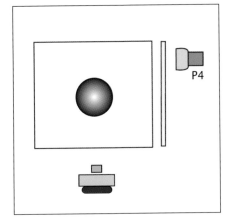

The panel is on the right side, parallel to the set. The strobe is in the bottom-right corner of the panel, or the P5 position. Most of the light is directed past the ball and off the set. Because the light is positioned to the rear of the set, it lights the back of the ball. The light is close and is powerful enough to wrap around the ball but falls off without a bounce card. The contact point shadow is still strong but has moved forward. The ball's dimension and depth has increased, but there is less definition in the ribbing. In conjunction with other lights, this is an optimal highlight.

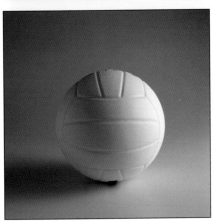

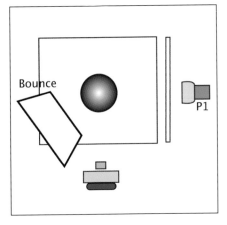

Bounce

The panel is on the right side, parallel to the set. The strobe is in the center of the panel, or the P1 position. A bounce card is placed on the left side of the set and fills in darker areas without creating new shadows.

The ball's dimension and depth are reduced because the light hits both sides of the ball. It appears dimensional, however, because the light on one side is still brighter. The ribs of the ball appear flatter but are more visible because they are not hidden in shadow. The background is still muted. The contact point shadow has moved to the side and is softer due to the light reflecting off the bounce card.

The panel is on the right side, parallel to the set. The strobe is in the top-right corner of the panel, or the P3 position. A bounce card is placed on the left side of the set to fill in darker areas without creating new shadows.

Because there is light hitting both sides of the ball, the overall look of the image is flat and gray. The ribs of the ball appear flatter and are less visible. The muted light causes the ball to appear less round. The background is still muted, and the shadow at the contact point is darker. There is a hard shadow going to the side of the ball that falls off quickly due to the light reflecting off the bounce card.

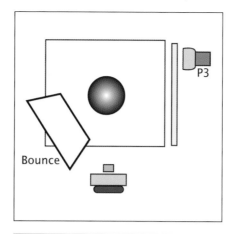 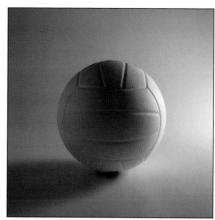

The panel is in the front-right corner of the set. The strobe is in the center of the panel, or the P1 position. This would be a great place to start off a main lighting position.

The ball's dimension and depth are enhanced by the light hitting the front of the ball. The overall look of the image is three dimensional with good separation from the background. The ribs of the ball appear flatter. There is a hard shadow going to the side of the ball that is long and dark. A bright spot can be identified on the ball. That is the area the viewer's eye will be drawn to first.

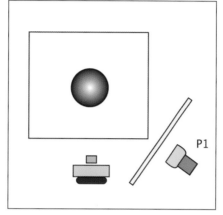 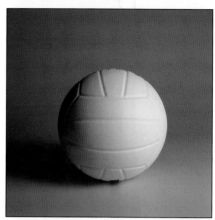

The panel is in the front-right corner of the set. The strobe is in the upper left of the panel, or the P2 position. In conjunction with other lights, this would be a nice fill light.

The ball's dimension and depth are reduced because the light hits the ball and set equally. With most of the light going over the top of the ball and off the set, the image is gray and monotone. The overall look of the image is two dimensional with poor separation from the background. The ribs of the ball appear flatter. There is a hard shadow going to the side of the ball that is short and dark.

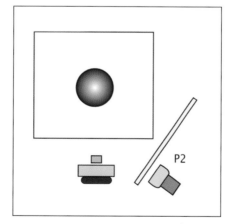 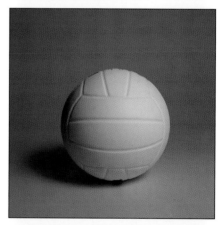

The panel is at the front-right corner of the set. The strobe is in the bottom left of the panel, or the P3 position. This would be a great place to start off a main lighting position. By placing a secondary light, we could better define the back of the ball and create separation.

The ball's dimension and depth are enhanced by the light hitting the front of the ball. The overall look of the image is two dimensional with excellent separation from the background. The ball's ribs appear flatter due to the brightness of the light, and there is a long, hard shadow to the back. There is a bright spot on the ball; this is the area that the viewer's eye will be drawn to first.

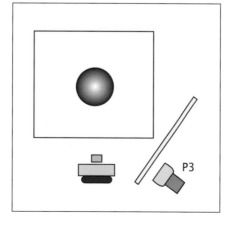 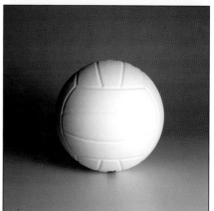

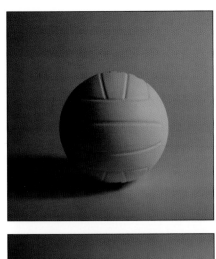

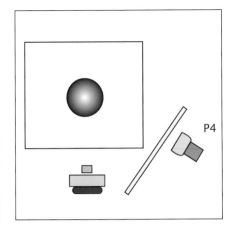

The panel is in the front-right corner of the set. The strobe is in the top right of the panel, or the P4 position.

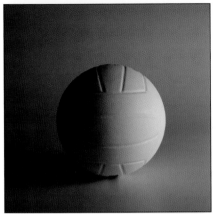

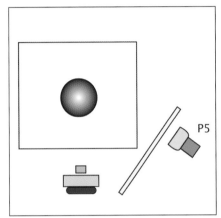

The panel is in the front-right corner of the set. The strobe is in the bottom right of the panel, or the P5 position.

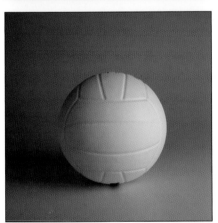

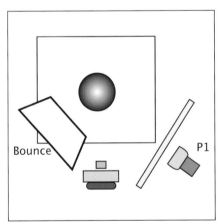

The panel is in the front-right corner of the set. The strobe is in the center of the panel, or the P1 position. A bounce card is added at an angle at the front-left corner of the set.

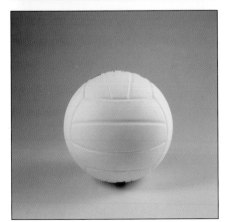

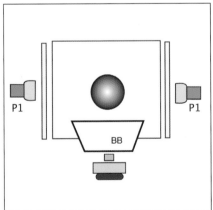

Two panels are positioned parallel to the set. The right-hand strobe is in the center of the panel, or the P1 position. The left-hand strobe is also in the P1 position. Both lights are on equal power settings. A bounce card is placed between the camera and the ball and reflects light upward from the bottom of the ball.

Two panels are parallel to the set. The right-hand strobe is in the center of the panel, or the P1 position. The left-hand strobe is in the upper left, or the P2 position. Both lights are on equal power settings. A bounce card is placed between the camera and the ball and reflects light upward from the bottom of the ball.

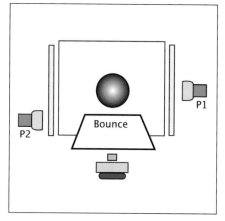

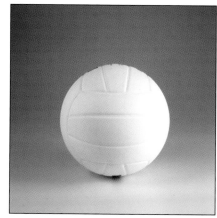

Two panels are parallel to the set. The right-hand strobe is in the lower left of the panel, or the P3 position. The left-hand strobe is in the upper left, or the P2 position. Both lights are on equal power settings.

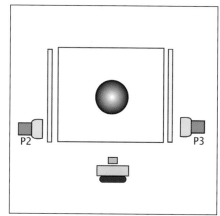

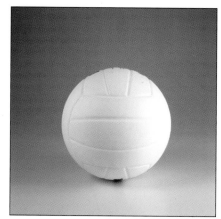

Two panels are parallel to the set. The right-hand strobe is in the lower right of the panel, or the P5 position. The left-hand strobe is in the upper right, or the P4 position. Both lights are on equal power settings.

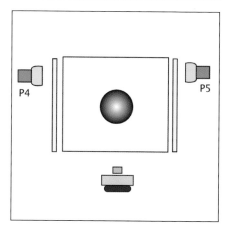

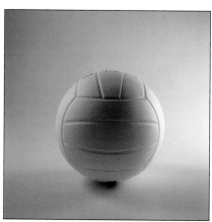

Two panels are parallel to the set. The right-hand strobe is in the center of the panel, or the P1 position. The left-hand strobe is also in the P1 position. Both lights are on equal power settings. A bounce card has been added to the set between the camera and the ball and reflects light upward from the bottom of the ball. A second bounce card is placed above the ball to reflect light downward.

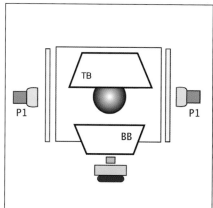

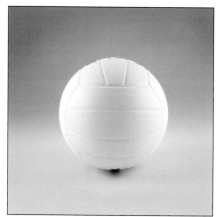

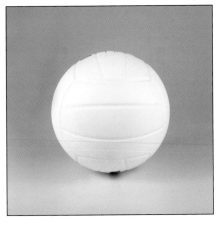
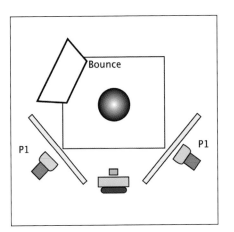

Two panels are in the front corners of the set. The right-hand strobe is in the center of the panel, or the P1 position. The left-hand strobe is also in the P1 position. Both lights are on equal power settings. A bounce card is placed to the back of the set to reflect light onto the back of the ball.

The equal lighting from either side flattens the ball and background. The overall lack of shadow lessens the sense of dimension. We can see the ribs easily, but without a good contact shadow, it is hard to determine the ball's weight and mass. The bounce card equalizes the light all the way around the ball.

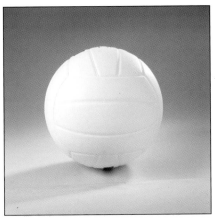
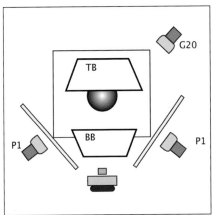

Two panels are in the front corners of the set. The right-hand strobe is in the center of the panel, or the P1 position. The left-hand strobe is also in the P1 position. The backlight, fitted with a 20-degree honeycomb grid, is aimed at the top of the ball. All three lights are on equal power settings. A bounce card is placed behind and above the subject; it reflects light onto the back of the ball and downward. This enhances the look of the surface. A bounce card between the camera and ball reflects light upward. The highlights separate the edge from the background. With the gradation of light, the ball maintains a three-dimensional shape.

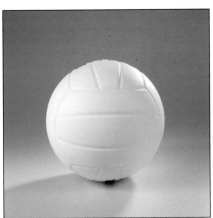
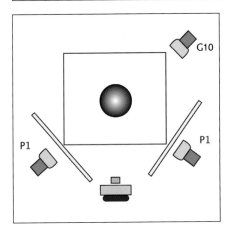

Two panels are in the front corners of the set. The right-hand strobe is in the center of the panel, or the P1 position. The left-hand strobe is also in the P1 position. The backlight, a strobe fitted with a 10-degree honeycomb grid, is aimed at the top of the ball. All three lights are on equal power settings. The ball appears three dimensional; the ribs show clearly in the front, and the specular highlight on the top-right back edge of the ball adds depth and helps create separation from the background. The ball still has the impression of weight and mass.

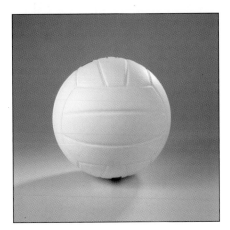
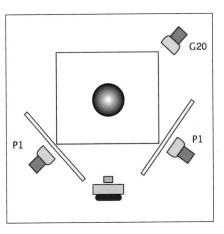

Two panels are in the front corners of the set. The right-hand strobe is in the center of the panel, or the P1 position. The left-hand strobe is also in the P1 position. The backlight, a strobe fitted with a 20-degree honeycomb grid, is aimed at the top of the ball. All three lights are on equal power settings.

Two panels are in the front corners of the set. The right-hand strobe is in the center of the panel, or the P1 position. The left-hand strobe is also in the P1 position. The backlight, a strobe fitted with a 30-degree honeycomb grid, is aimed at the top of the ball. All three lights are on equal power settings.

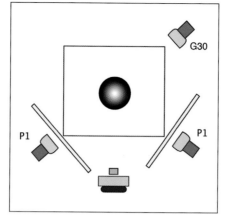

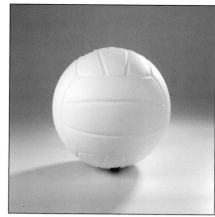

Two panels are in the front corners of the set. The right-hand strobe is in the center of the panel, or the P1 position. The left-hand strobe is also in the P1 position. The backlight, a strobe fitted with a 40-degree honeycomb grid, is aimed at the top of the ball. All three lights are on equal power settings.

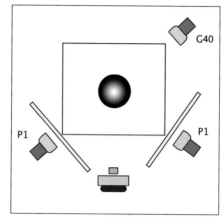

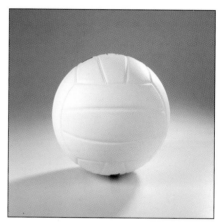

Two panels are in the front corners of the set. The right-hand strobe is in the upper left of the panel, or the P2 position. The left-hand strobe is at the bottom left of the panel, or the P5 position. The backlight, a strobe fitted with a 20-degree honeycomb grid, is aimed at the top of the ball. All three lights are on equal power settings.

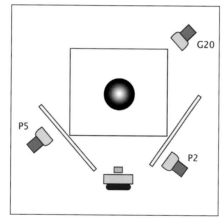

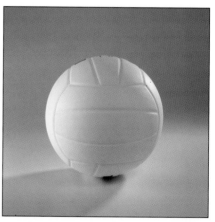

A single panel is placed at an angle at the front-left corner of the set. The strobe is in the center of the panel, or the P1 position. The backlight, a strobe fitted with a 20-degree honeycomb grid, is aimed at the top of the ball. Both lights are on equal power settings.

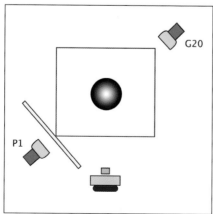

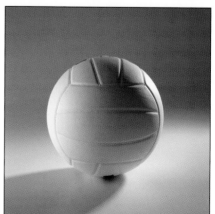

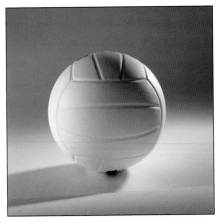

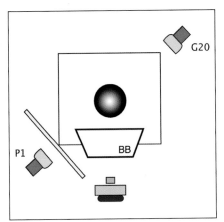

The panel is placed at an angle at the front-left side of the set. The strobe is in the center of the panel, or the P1 position. The backlight, a strobe fitted with a 20-degree honeycomb grid, is aimed at the top of the ball. Both lights are on equal power settings. A bounce card is added to the set between the camera and the ball and reflects light upward from the bottom of the ball.

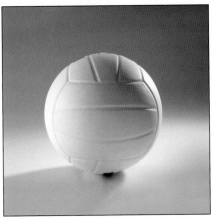

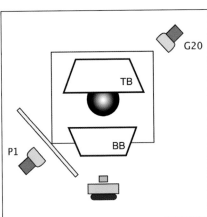

The panel is placed at an angle at the front-left side of the set. The strobe is in the center of the panel, or the P1 position. The backlight, a strobe fitted with a 20-degree honeycomb grid, is aimed at the top of the ball. Both lights are on equal power settings. A bounce card is added to the set between the camera and the ball and reflects light upward from the bottom of the ball. A bounce card is also placed above the ball to reflect light downward.

Using light, we have changed the apparent size and weight of the volleyball. In this image, the depth and curvature of the ribs of the ball are defined by the light, which wraps around the ball and adds a certain sparkling, skin-like texture. The brightness of the light on either side of the center emphasizes the round shape of the ball. The overall use of light and shadow in the image create a feeling of a third dimension in the two-dimensional medium. It's a perfectly clean ball ready to be picked up and used for sport.

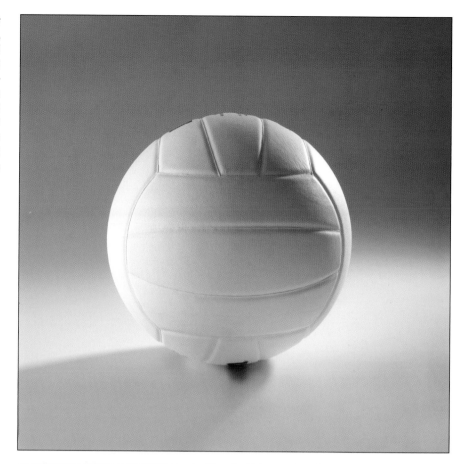

This darker photo of the ball is much more dramatic. The darker shadow on the left side flattens the shape of the ball as its color slides into the shadow on the floor of the backdrop. The lines on the brighter side of the ball seem to merge into darkness as well, diminishing the feeling of dimensionality in the image. This does not mean that the image is not a success. In this image, the long shadow was produced in order to create mood. Viewers likely know that a volleyball is white, round, and inflated. By using light, we purposefully created a sense of mystery and loneliness. A little mystery goes a long way in advertising.

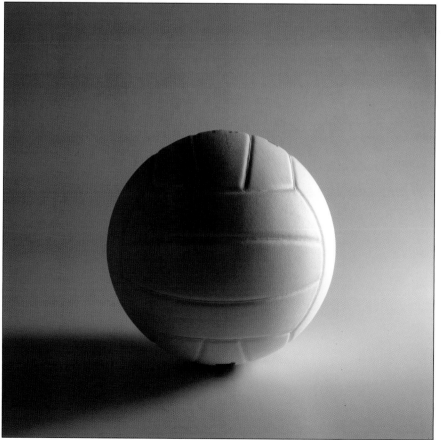

6. Honeycomb Grids

A honeycomb grid is a modifier that typically fits inside the strobe's reflector dish and forces the light to travel in a straight line. The most popular types are the 10-, 20-, 30-, and 40-degree grids, but some manufacturers offer an ultraprecise 5-degree honeycomb grid. By attaching honeycomb grids to your strobes, you get complete control over the beams of light illuminating the subject.

Control over light is a must. However, don't confuse masterful lighting with excessive, overly complicated lighting. Be sure that any light you add to your set serves a clear purpose. Light without purpose can confuse your set, confuse you, and confuse your client.

A strobe fitted with a 20-degree honeycomb grid is placed at an angle in the front-right corner of the set and aimed at the statue. As you read each description that follows, assume that the light is being used on full power and the camera is in a fixed position on a camera stand.

The photos in this chapter were taken by Robert Morrissey and Justin LeVett.

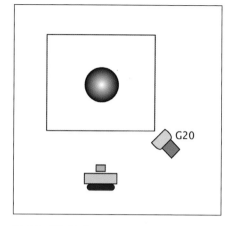

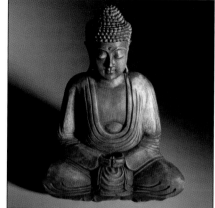

A strobe fitted with a 20-degree honeycomb grid is placed at the right side of the set and aimed at the statue.

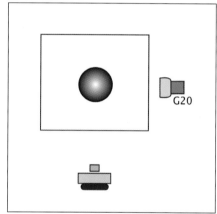

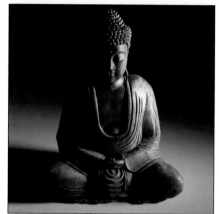

A strobe fitted with a 20-degree honeycomb grid is placed at the back-right corner of the set and aimed at the statue.

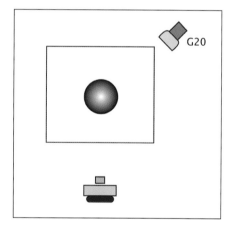

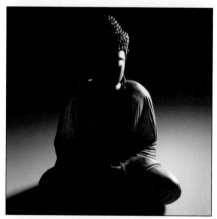

A strobe fitted with a 20-degree honeycomb grid is placed at the back-right corner of the set and aimed at the statue. A second strobe fitted with a 20-degree honeycomb grid is placed at the front-left corner of the set and aimed at the statue.

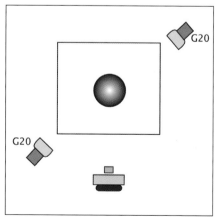

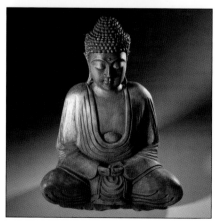

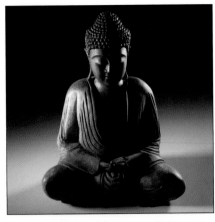
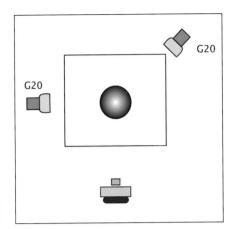

A strobe fitted with a 20-degree honeycomb grid is placed at the back corner of the set and aimed at the statue. A second strobe fitted with a 20-degree honeycomb grid is placed to the left side of the set and aimed at the statue.

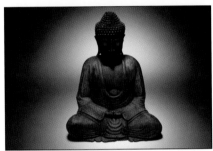
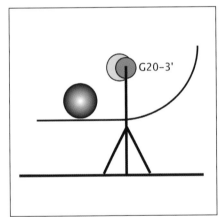

A strobe fitted with a 10-degree honeycomb grid is aimed at the top of the statue from an overhead position. A second strobe is fitted with a 20-degree honeycomb grid and mounted on a boom stand. This light is pointed at the backdrop.

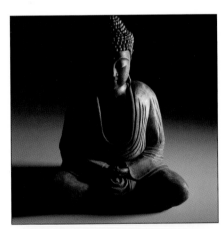
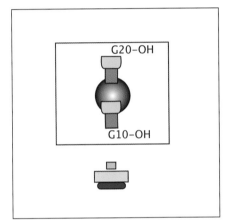

A strobe fitted with a 20-degree honeycomb grid is placed at the side of the set at a height of 3 feet and aimed at the statue.

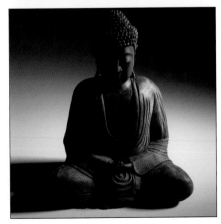
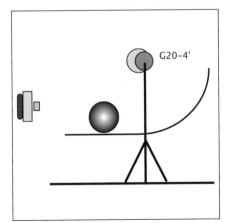

A strobe fitted with a 20-degree honeycomb grid is placed at the side of the set at a height of 4 feet and aimed at the statue.

A strobe fitted with a 20-degree honeycomb grid is placed at the side of the set at a height of 5 feet and aimed at the statue.

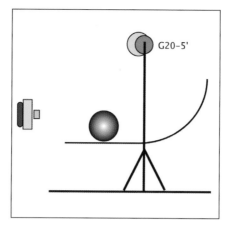

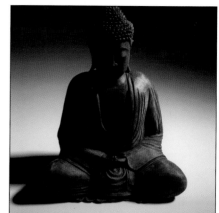

A light is fitted with a 20-degree honeycomb grid and is placed at the back-right corner of the set and aimed at the statue. A second strobe is fitted with a 20-degree honeycomb grid, placed at the front-left corner of the set, and aimed at the front of the statue. A bounce card is added in between the camera and the statue and is angled upward to bounce the light back into the statue.

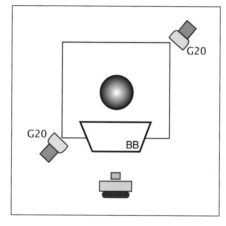

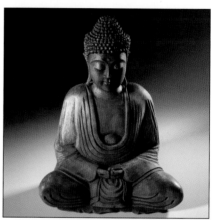

A strobe fitted with a 20-degree honeycomb grid is placed at the back-right corner of the set and aimed at the statue. A second strobe fitted with a 20-degree honeycomb grid is placed at the front-left corner of the set and aimed at the front of the statue. A bounce card is added in between the camera and the statue and is angled upward to bounce light back into the statue. A second bounce card is added above the statue and is angled inward to reflect light onto the statue.

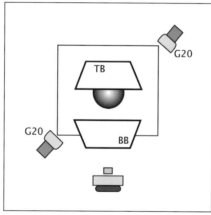

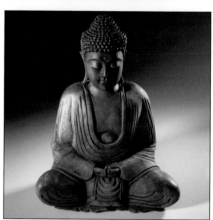

A strobe fitted with a 20-degree honeycomb grid is placed at the front-right corner of the set and aimed at the statue. A second strobe fitted with a 30-degree honeycomb grid is aimed at the back top of the statue. A round mirror is added to the front left of the set and reflects light back into the statue.

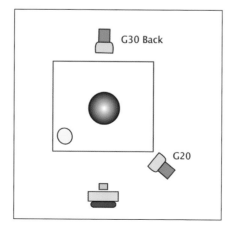

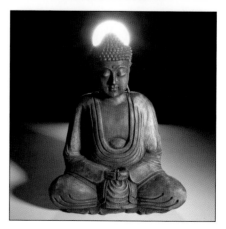

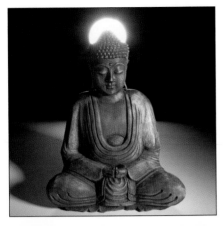

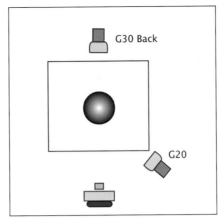

A strobe fitted with a 20-degree honeycomb grid is placed at the front-right corner of the set and aimed at the statue. A second strobe fitted with a 30-degree honeycomb grid is aimed at the back top of the statue.

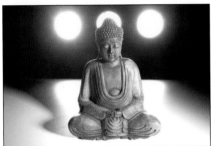

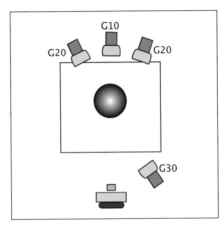

A strobe fitted with a 30-degree honeycomb grid is placed at the front-right corner of the set and aimed at the statue. A second strobe is fitted with a 10-degree honeycomb grid and aimed at the back top of the statue. The third and fourth strobes are fitted with 20-degree honeycomb grids and are positioned on either side of the backlight, aimed at the camera lens.

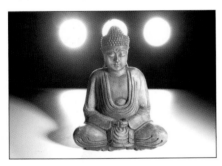

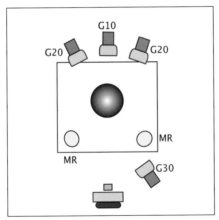

A strobe fitted with a 30-degree honeycomb grid is placed at the front corner of the set and aimed at the statue. A second strobe is fitted with a 10-degree honeycomb and aimed at the back top of the statue. A third and fourth light are fitted with 20-degree honeycomb grids and positioned on either side of the back-light. These lights are aimed at the camera lens. Two round mirrors are added to the front corners of the set to reflect the backlight into the statue.

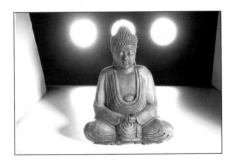

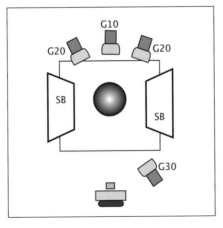

A strobe fitted with a 30-degree honeycomb grid is placed at the front-right corner of the set and aimed at the statue. A second strobe is fitted with a 10-degree honeycomb grid and aimed at the back top of the statue. A third and fourth strobe are fitted with a 20-degree honeycomb grid and are positioned on either side. These lights are aimed at the camera lens. A bounce card is added to either side of the set to reflect the backlight into the statue.

A strobe fitted with a 20-degree honeycomb grid is placed at the front-right corner of the set and aimed at the statue. A second light is fitted with a 30-degree honeycomb grid and aimed at the back top of the statue from above the background. A third strobe is fitted with a 10-degree honeycomb grid. It is placed on the left of the set and aimed behind the statue and onto the background. A round mirror is added to the front-left corner of the set to reflect the backlight into the statue. A black card is added to the right side to block the first light from hitting the background.

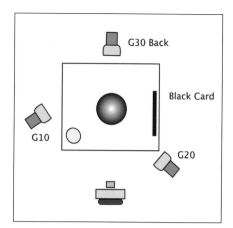

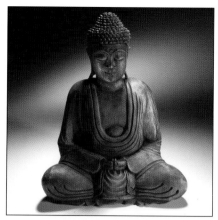

A strobe fitted with a 20-degree honeycomb is placed at the front-right corner of the set and aimed at the statue. A strobe set to low power is fitted with an umbrella. It is placed behind the first light to produce a wide fill light. A third strobe is fitted with a 20-degree honeycomb grid and placed on the right side, aimed at the statue's shoulder. A black card is used to block this light from hitting the background. The fourth light, fitted with a 10-degree honeycomb grid, is placed on the left of the set and aimed at the statue's shoulder. A black card is used to block this light from hitting the background. Two mirrors are added to reflect the backlight into the front of the statue.

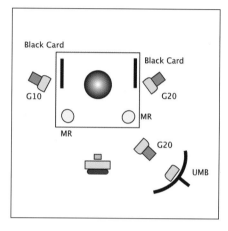

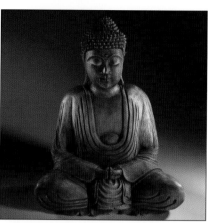

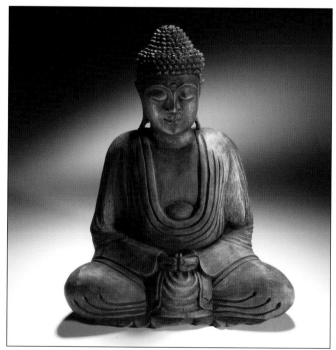

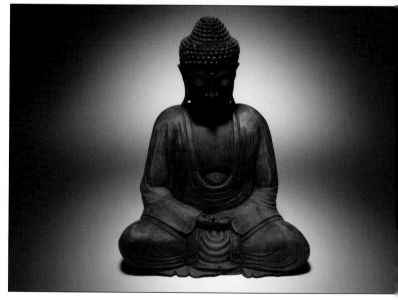

As you can see here, you can create two completely different looks with the same set and same objects. The left image shows the result of using a lighting setup that brings out every nuance of the statue. The photo on the right is much darker and more dramatic. Both images will sell the object, and both are perfectly exposed, but there is a big difference in the lighting effect from one shot to the next.

Lighting is the very soul of an image. It can create bright and cheery images or dark and moody ones. In these examples, the differences are pronounced.

7. Umbrellas

Umbrellas can be found in the toolkits of most photographers. These umbrella-shaped modifiers attach to a strobe head and produce a soft, directional light. The material used to line the interior of an umbrella affects the light that is produced. Umbrellas with silver linings produce a cooler light than do umbrellas with a gold-colored interior. Umbrellas made with a white interior create a higher level of diffusion but do not impact the color of the light produced.

To produce the series of portraits of our model, Mia, in this chapter, I used umbrellas with a white lining.

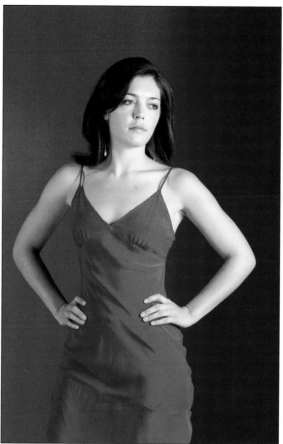

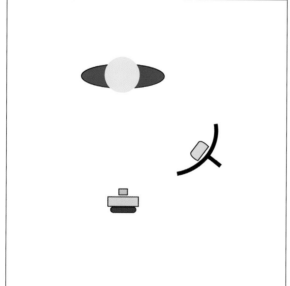

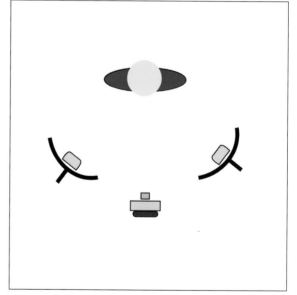

An umbrella is placed in the front-right corner of the set and is aimed at the subject at a 45-degree angle. The light is on full power.

An umbrella is placed in the front-right corner of the set. A second umbrella is placed in the front-left corner of the set. Both umbrellas are aimed at the subject at a 45-degree angle, and both lights are on full power.

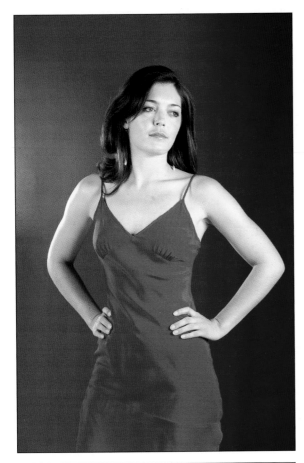

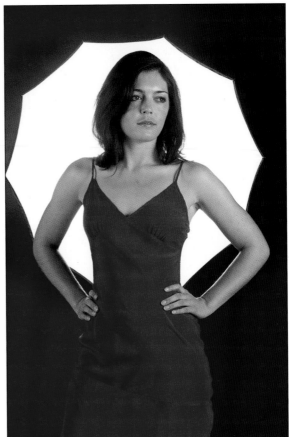

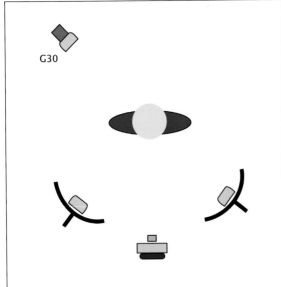

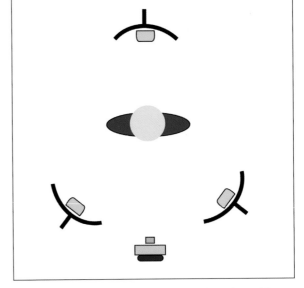

The first umbrella is placed on the right side of the set. The second umbrella is placed on the left side of the set. The umbrellas are aimed at the subject at a 45-degree angle, and both lights are on full power. The third light is fitted with a 30-degree honeycomb grid and is aimed at the model's hair. The gridded light is on low power.

The first umbrella is placed on the right side of the set. The second umbrella is placed on the left side of the set. The umbrellas are aimed at the subject at a 45-degree angle, and both lights are on full power. The third umbrella is directly behind the subject and is aimed straight at the camera. The subject blocks the majority of the light, reducing flare. This third light is on low power.

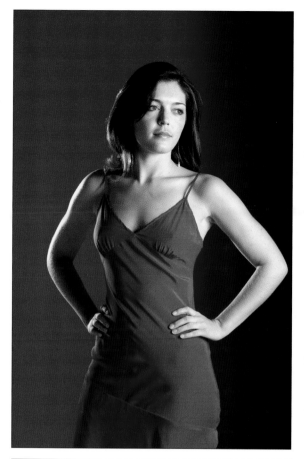

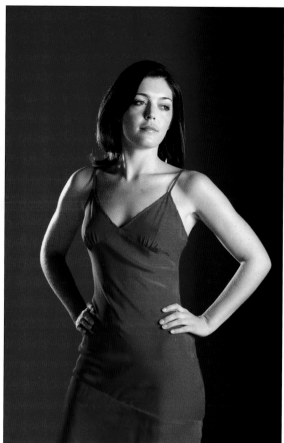

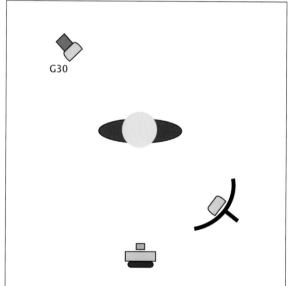

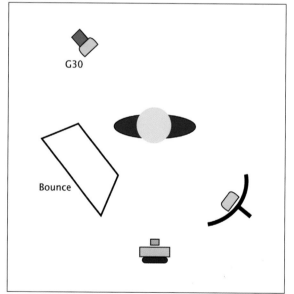

An umbrella is placed in the front-right corner of the set and is aimed at the subject at a 45-degree angle. A strobe light fitted with a 30-degree honeycomb grid is placed at the back-left corner of the set and is aimed at the subject's hair. Both lights are on full power.

An umbrella is placed in the front-right corner of the set and is aimed at the subject at a 45-degree angle. A strobe is fitted with a 30-degree honeycomb grid, placed in the back-left corner of the set, and aimed at the subject's hair. Both lights are on full power. A bounce card is added to the camera-left side of the set and reflects light from the umbrella back onto the model.

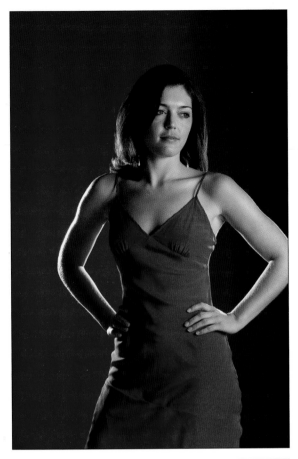

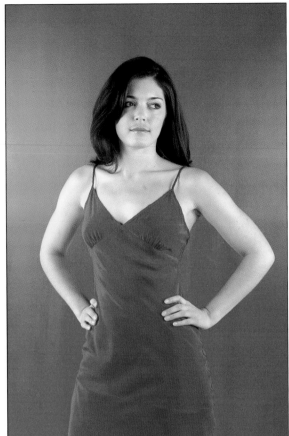

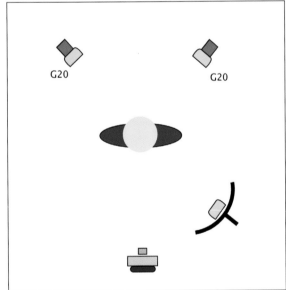

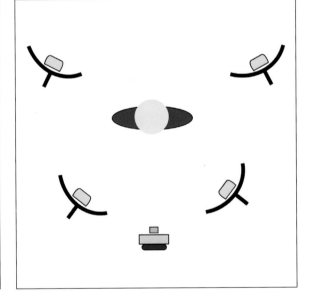

G20

G20

A strobe fitted with an umbrella is placed in the front-right corner of the set. The umbrella is aimed at the subject at a 45-degree angle. Two strobes, each fitted with a 20-degree honeycomb grid, are aimed at the subject's hair from the back corners of the set. All three lights are on full power.

One umbrella is placed in the front-right corner of the set. A second umbrella is placed at the front-left corner of the set. These lights are aimed at the subject at a 45-degree angle. An umbrella is placed in each of the back corners of the set. These are aimed at the background at a 30-degree angle. All four lights are on full power.

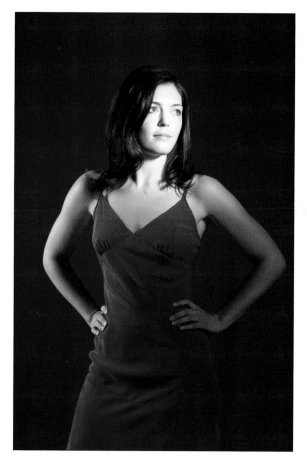

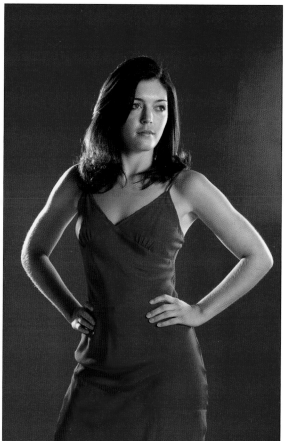

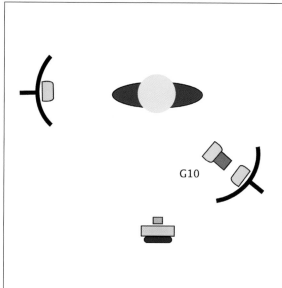

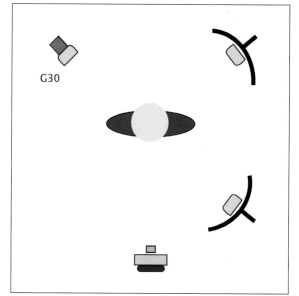

An umbrella is placed in the front-right corner of the set. A second umbrella is placed to the left of the subject. Both umbrellas are on full power. A strobe fitted with a 10-degree honeycomb grid is placed directly in front of the first umbrella, aimed at the subject's face. This light is on low power.

An umbrella is placed in the front-right corner of the set and is aimed at the subject at a 45-degree angle. A second umbrella is placed in the back-right corner of the set and is aimed at the subject at a 45-degree angle. A strobe is fitted with a 30-degree honeycomb grid and aimed at the subject's hair. All three lights are on full power.

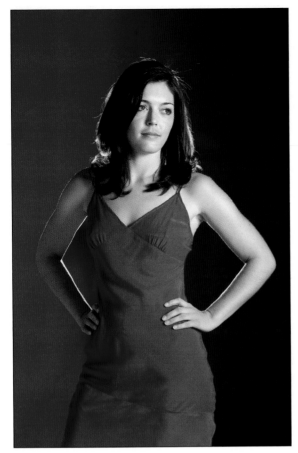 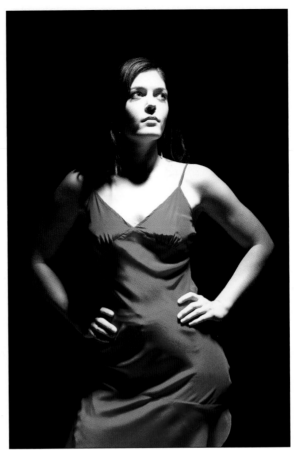

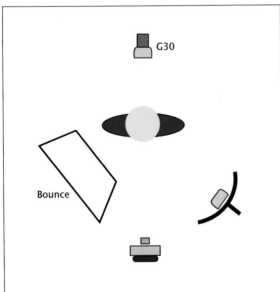 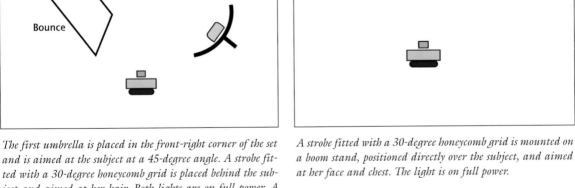

The first umbrella is placed in the front-right corner of the set and is aimed at the subject at a 45-degree angle. A strobe fitted with a 30-degree honeycomb grid is placed behind the subject and aimed at her hair. Both lights are on full power. A bounce card is added to the left side of the subject, bouncing in the light from the umbrella.

A strobe fitted with a 30-degree honeycomb grid is mounted on a boom stand, positioned directly over the subject, and aimed at her face and chest. The light is on full power.

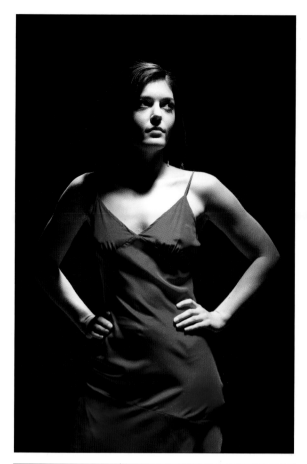

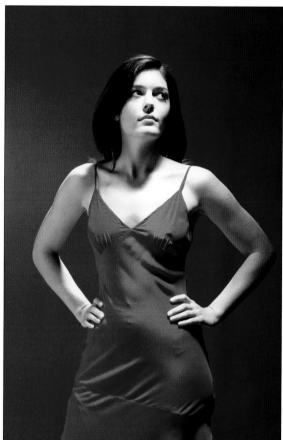

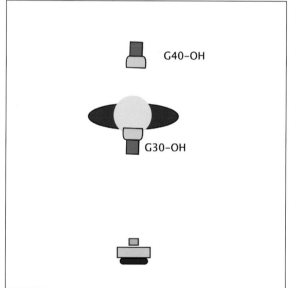

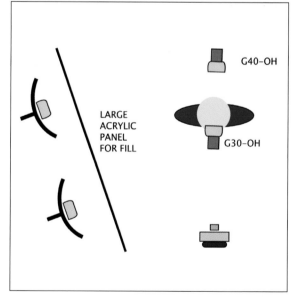

A strobe fitted with a 30-degree honeycomb grid is mounted on a boom stand, positioned directly over the subject, and aimed at her face and chest. Using a second studio boom stand, we positioned a light fitted with a 40-degree honeycomb grid directly over the subject and aimed at the back and shoulders. Both lights are on full power.

A strobe fitted with a 30-degree honeycomb grid is mounted on a boom stand, positioned directly over the subject, and aimed at her face and chest. Using a second studio boom stand, we positioned a light fitted with a 40-degree honeycomb grid directly over the subject and aimed at the back and shoulders. Both lights are on full power. Two umbrellas are placed on the left side of the set and aimed at the subject. A 4x8-foot panel is added to diffuse the light from the umbrellas on the left side.

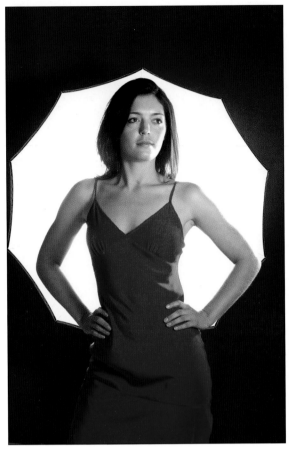

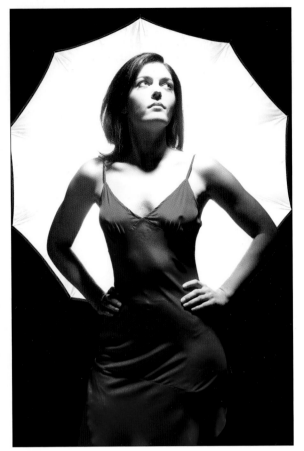

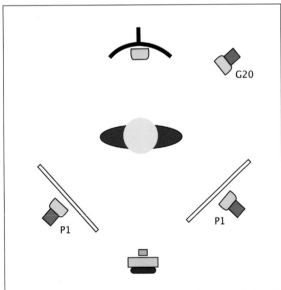

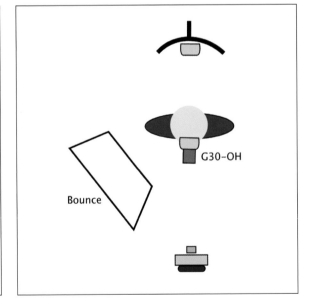

Panels are placed on the right and left sides of the subject, with each light in the P1 position. The panel lights are on full power. The third light is an umbrella placed directly behind the subject and aimed at the camera. It is on low power. The fourth light is fitted with a 20-degree honeycomb grid and aimed at the subject's hair. The gridded light is on full power.

A strobe fitted with a 30-degree honeycomb grid is mounted on a boom stand, positioned directly over the subject, and aimed at her face and chest. The light is on full power. The second light is an umbrella placed behind the subject aimed directly at the camera. The umbrella is on low power. A large bounce card is added to the left side to reflect the light back onto the subject.

This image seems sterile in some ways. The portrait is exposed correctly. The highlights on the back of the model's hair and on her skin are correct. The light on her face is flattering and does not promote any imperfections. The wrinkles on the dress tell the story of fabric and fit. The background fades evenly from red to a darker, muted color in the red spectrum.

Despite its technical graces, the rendition of the model's face is bland. Even if a photo is technically correct, you'll find that you sometimes need to add a little something to make it work.

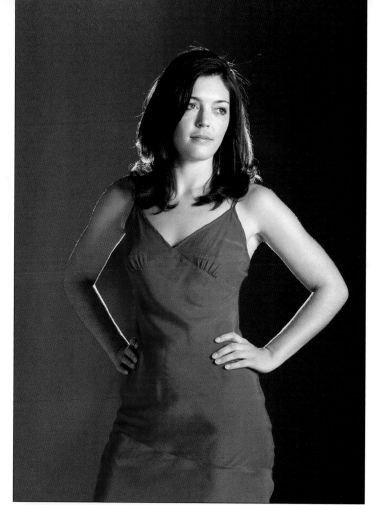

This image has what the previous one lacks. Drama, sex appeal, and a little finesse are all wrapped into one tight photographic package. The giant umbrella behind the model frames her body with white light, and the illumination creates a glimmer on her skin and hair. The front light smoothes her skin, allowing her dramatic features to stand out.

The downward shadows created by the high front light almost make her dress appear see-through, and gives you a good feel for how tight the garment is. Her upward stare is emphasized by the shadows under her brows. This risky technique takes a lot of practice, but the result is well worth it. What you are looking for is the perfect mix of light shooting into the lens plus correct exposure on your subject. One move to either side of the model, and the flare ruins the shot.

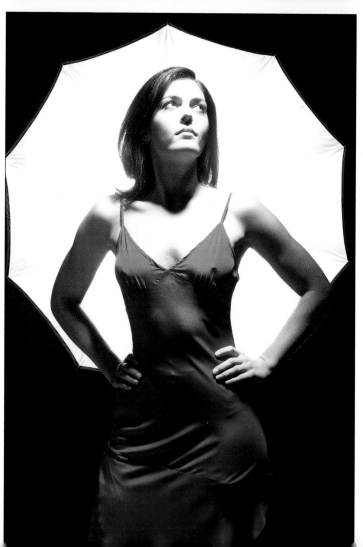

Using Umbrellas Outdoors

Using studio lights outdoors can be a great way to create signature images. Viewers will respond to the high-impact lighting effects this technique produces. With battery-powered light packs, producing this look has eliminated the need for generators or complex flash systems when working outdoors, so there's no excuse for not giving this technique a try.

With the outdoor umbrella technique, there are two strategies at your disposal. The first option is to make the sun work for you and select an overall exposure that is equal to the ambient light. The second is to overpower the natural light, making it less important in the shot, by setting your studio unit to cast light that is one or more stops brighter than the sunlight. This creates perfect separation between the subject and the background. Keep in mind that you can also use this techniques at different times of day. Simply determine how much (or little) sunlight you need in your image, then select the time of day you should shoot. Day or night, using studio lighting outdoors can produce great results.

When judging your exposure on this type of shoot, I suggest evaluating the image histogram on your camera or computer. When the sky is included in the image, I recommend exposing for it to ensure that you capture the needed detail in this area. You could put a new sky into the shot in post-production, but it's better not to have to do it.

Finally, when taking your studio lights outside, safety becomes a serious concern. I shouldn't have to tell you not to shoot in the rain, but I had to learn the hard way, so I figure others might be tempted as well. Keep in mind, as well, that wind can be problematic when using studio lights outdoors. I always use fifteen-pound weights on the bottom of any light stand that has an umbrella on it. Even so, over the years I have broken lights, stands, heads, and even the screen of the computer I used to write this book.

In the following series of outdoor images, we'll look at the effects of changing the positions of the model relative to the sun and using umbrellas to create a desirable lighting effect. For all of these shots, the sun was high and to the left behind a great wall of clouds. The images were shot using a 35mm lens and with an exposure setting of f/16 at $\frac{1}{90}$ second. For the shots with the truck, I made sure to keep the windows down to reduce glare and let as much light as possible shine through. Throughout the series, the camera was handheld.

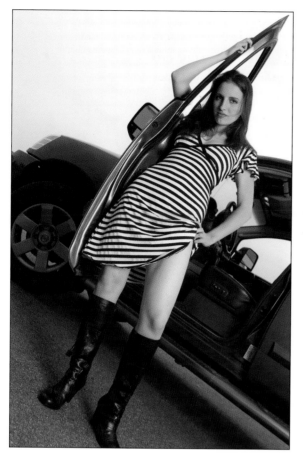

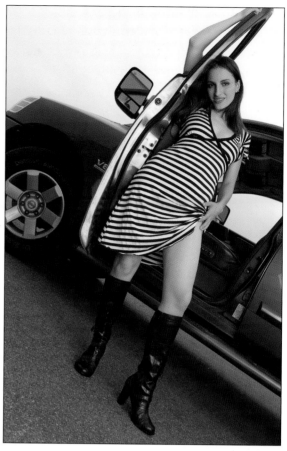

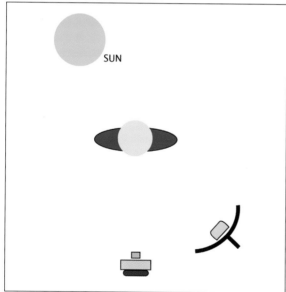

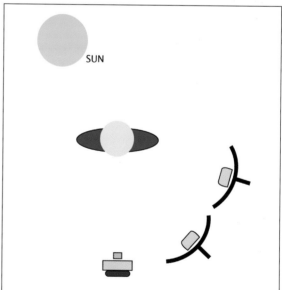

An umbrella is placed to camera right and set on full power. The umbrella is aimed at the subject at a 45-degree angle. The sun is behind and to the side of the subject, so the camera does not have to fight flare. In this case, the umbrella works as a fill light. It is matched evenly with the sun and creates a perfect 3-D effect on the subject.

Two umbrellas are placed on the right side of the set. Both lights are on full power. The umbrellas are aimed at the subject at a 45-degree angle. Notice how the lighting appears a bit flatter than in the previous image. Using two lights increased the forward detail and reduced the shadows.

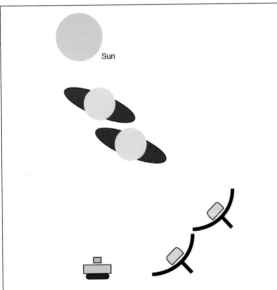

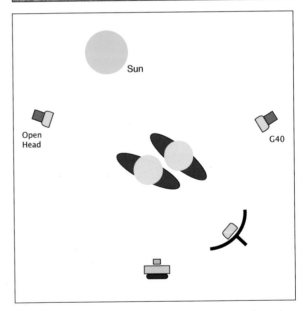

Left—Here's the true test of this lighting setup—using it with two models. To create this image, I left the lights exactly as they were in the previous shot and just moved the models around. As you can see, umbrellas are a great match for sunlight, producing light that is not too focused but not too soft. It seems to flatter the subject every time.

Right—For this shot, I added to the previous lighting setup. In addition to the single full-power umbrella placed to camera right, an open head at 50 percent power is placed to camera left. The umbrella and open head are almost pointing directly at one another. A portion of the light from the open head hits the lens, but this reads like bright sunlight in the image. The third light used in this setup is a 40-degree honeycomb grid placed to camera right behind the subjects. This light, set at full power, is aimed toward the back subject's hair.

While we were creating these shots the sun was beginning to set. As the sky became darker, I was able to force the bright sun/dark sky effect by adjusting my aperture and the placement of my lights.

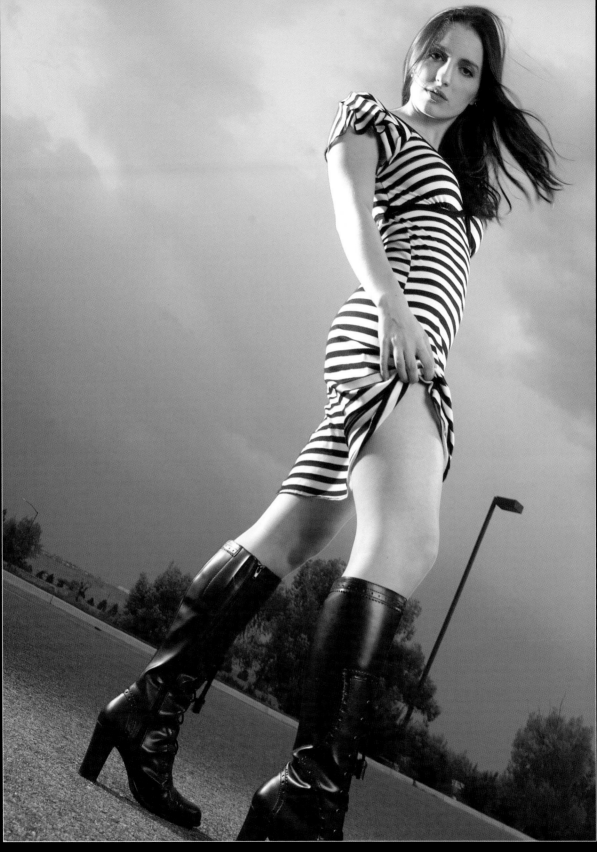

Here, the same lighting setup was used, but with a single subject and a low camera angle for a more dramatic shot.

8. Softboxes

*S*oftboxes create a soft overall light that looks natural and warm and is perfect for many portraits and other lighting sets. The main drawback of the softbox is that the light is centered within the box. Therefore, it can be more difficult to slightly adjust the light's position when using a softbox than if using a lighting panel. Every photographer should strive to control the light as much as possible.

Softboxes come in many shapes and sizes, so choose the type that best suits your needs. (*Note:* A medium thin softbox can be used in a vertical or horizontal direction; this makes it a good, versatile part of your lighting kit.)

Each of the following images in this series was made using an 80mm lens, and in each shot, the lights were used at full power. For each image, the subject was positioned on a tape mark on the floor. Natalie Cass was my assistant for this shoot, and Mia was our model.

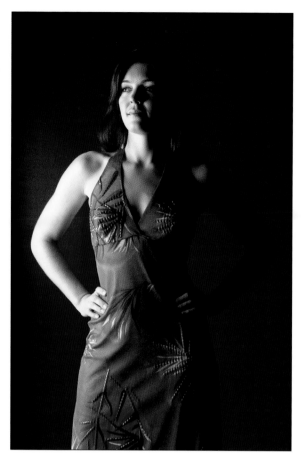

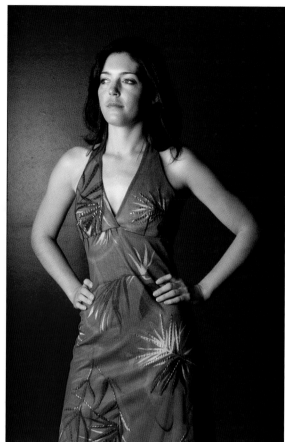

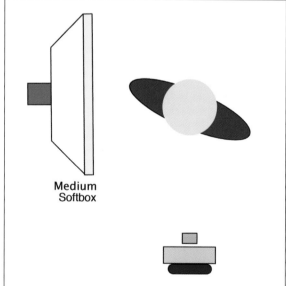

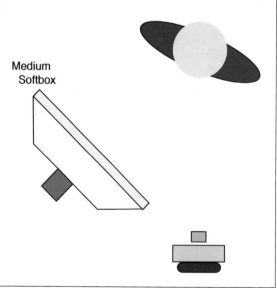

A medium softbox on a large studio stand is positioned at the left of the set. The light is at a 90-degree angle to the subject and is on full power.

A medium softbox on a large studio stand is positioned at the left of the set. The light is at a 45-degree angle to the subject and is on full power.

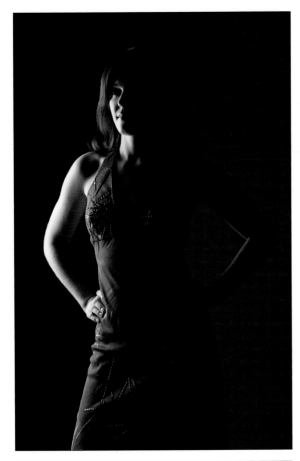

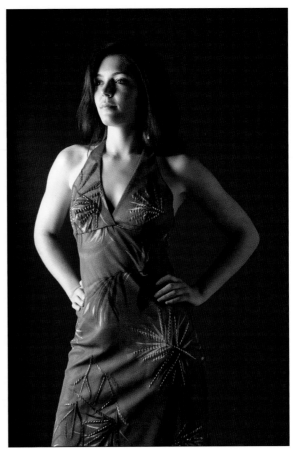

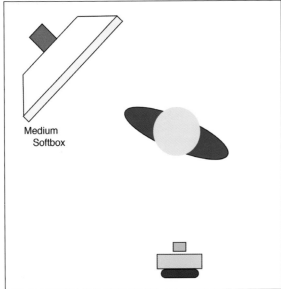

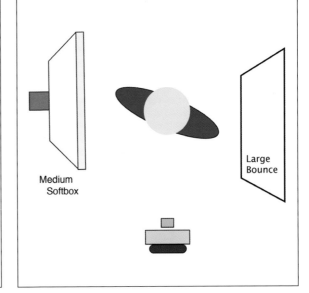

A medium softbox on a large studio stand is positioned to the left rear of the set. The light is at a 45-degree angle to the subject.

A medium softbox on a large studio stand is positioned at the left of the set. The light is at a 90-degree angle to the subject. A 6-foot tall white bounce card is positioned across from the softbox. It is used to reflect light back onto the subject, adding more detail to the face and body.

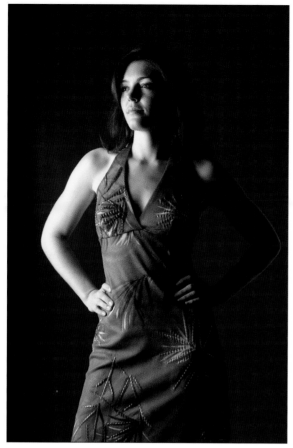 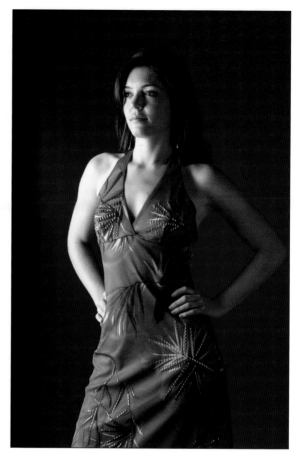

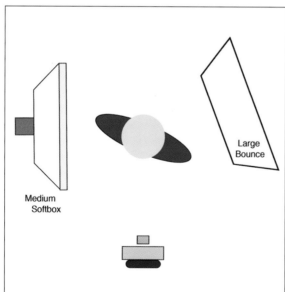 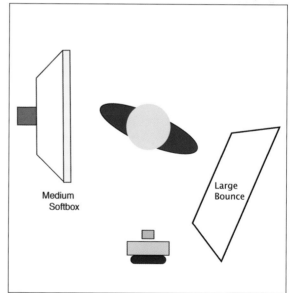

A medium softbox on a large studio stand is positioned at the left of the set. The light is at a 90-degree angle to the subject and is on full power. A 6-foot tall white bounce card is placed behind the subject on the right side of the set at a 45-degree angle to the subject. This bounce card reflects the light back into the subject, creating separation from the background.

A medium softbox on a large studio stand is positioned at the left of the set. The light is at a 90-degree angle to the subject and is on full power. A 6-foot tall white bounce card is positioned in front of the subject on the right side at a 45-degree angle. This bounce card is used to bring the light back into the subject, adding more detail to the face and body.

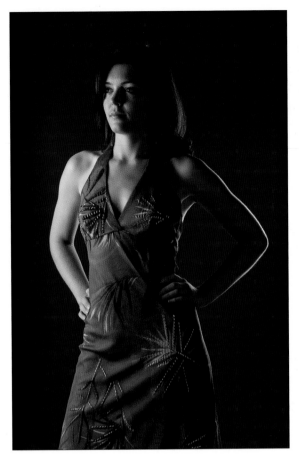

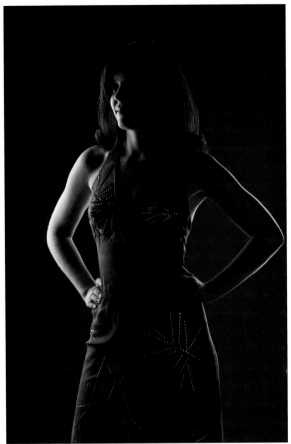

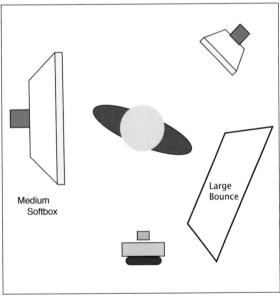

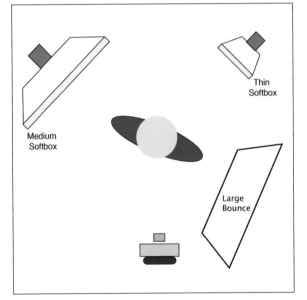

A medium softbox on a large studio stand is positioned at the left of the set. The light is at a 90-degree angle to the subject. The light is on full power. A 6-foot tall white bounce card is positioned in front of the subject on the right side at a 45-degree angle. This bounce card is used to bring the light back into the subject, adding more detail to the face and body. A thin vertical softbox is placed in the back-right corner aimed at the subject. This light creates highlights around the subject that ensure her separation from the background.

A medium softbox on a large studio stand is positioned at the left rear of the set. The light is at a 45-degree angle to the subject and is on full power. A 6-foot tall white bounce card is positioned at the front-right corner of the set and is aimed at the subject at a 45-degree angle. This bounce card reflects light back into the subject, adding more detail to the face and body. A thin vertical softbox is placed in the back-right corner and aimed at the subject. This light creates highlights around the subject that ensure her separation from the background.

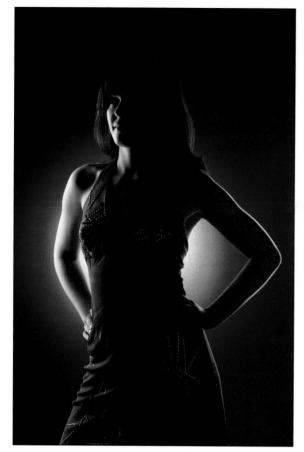

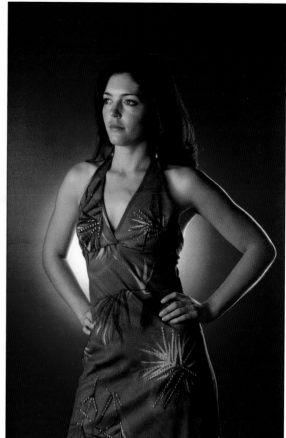

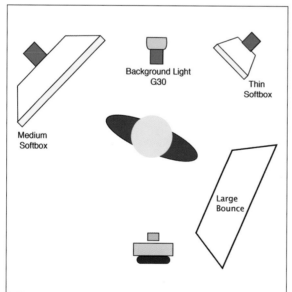

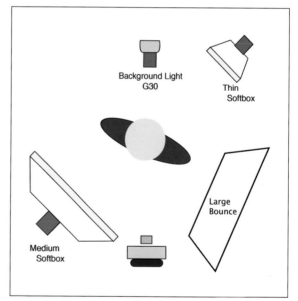

A medium softbox on a large studio stand is positioned at the left of the set. The light is at a 90-degree angle to the subject. A 6-foot tall white bounce card is positioned in front of the subject on the right side at a 45-degree angle. This bounce card is used to bring the light back into the subject, adding more detail to the face and body. A thin vertical softbox is placed in the back-right corner and aimed at the subject. This light creates highlights around the subject that ensure her separation from the background. A strobe fitted with a 30-degree honeycomb grid is aimed at the background. This creates a halo effect in the shot.

A medium softbox on a large studio stand is positioned at the left of the set. The light is at a 90-degree angle to the subject. A 6-foot tall white bounce card is positioned in front of the subject on the right side at a 45-degree angle. This bounce card is used to bring the light back into the subject, adding more detail to the face and body. A thin vertical softbox is placed in the back-right corner aimed at the subject. This light creates highlights around the subject that ensure her separation from the background. A strobe fitted with a 30-degree honeycomb grid is aimed at the background. This creates a halo effect in the shot.

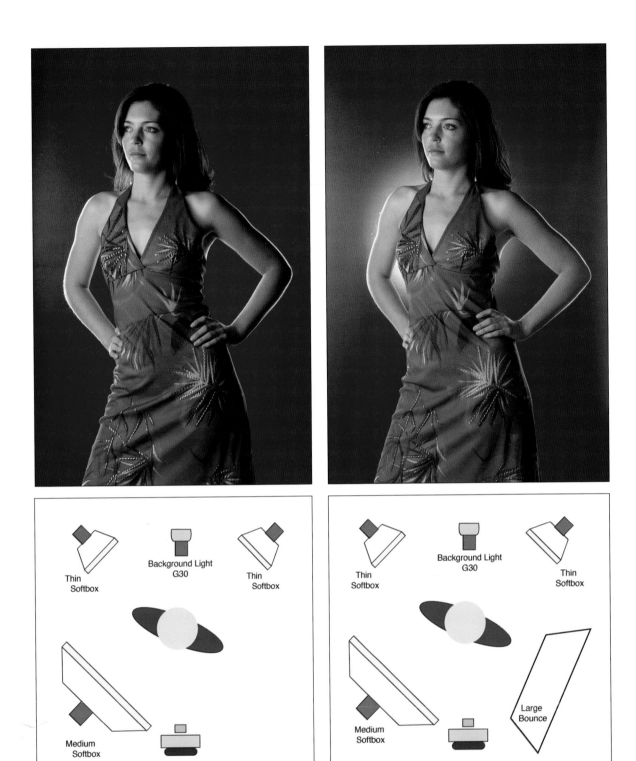

Left—*A medium softbox on a large studio stand is positioned at the left of the set. The light is at a 90-degree angle to the subject. Two thin vertical softboxes are placed in the back corners and are aimed at the subject. They create highlights around the subject that ensure her separation from the background. A strobe fitted with a 30-degree honeycomb grid is aimed at the background. This creates a halo effect in the shot.*

Right—*A medium softbox on a large studio stand is positioned at the front-left corner of the set. The light is at a 90-degree angle to the subject and is on full power. A 6-foot tall white bounce card is positioned in front of the subject on the right side at a 45-degree angle. It is used to bring the light back into the subject, adding more detail to the face and body. Two thin vertical softboxes are placed in the back corners of the set and are aimed at the subject. They create highlights around the subject that ensure her separation from the background. A strobe fitted with a 30-degree honeycomb grid is aimed at the background. This creates a halo effect in the shot.*

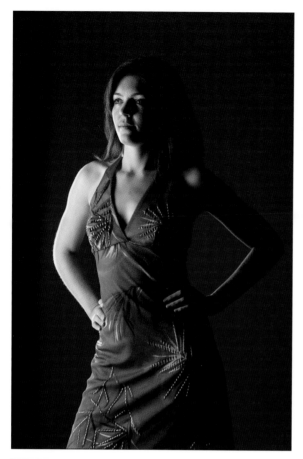

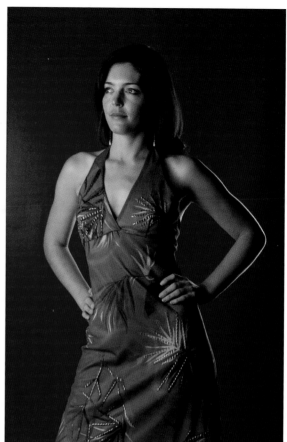

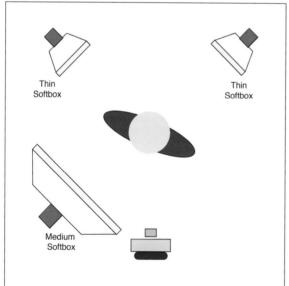

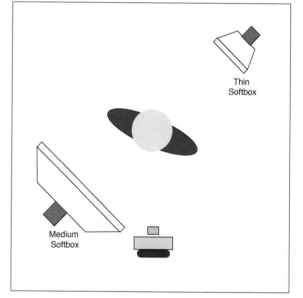

A medium softbox on a large studio stand is positioned at the front-left corner of the set. The light is at a 90-degree angle to the subject. Two thin vertical softboxes are placed in the back corners of the set and aimed at the subject. They create highlights around the subject that ensure her separation from the background.

A medium softbox on a large studio stand is positioned at the front-left corner of the set. The light is at a 45-degree angle to the subject. A thin vertical softbox is placed in the back-right corner aimed at the subject. It creates highlights around the subject that ensure her separation from the background.

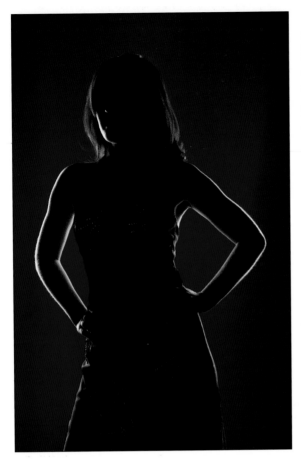

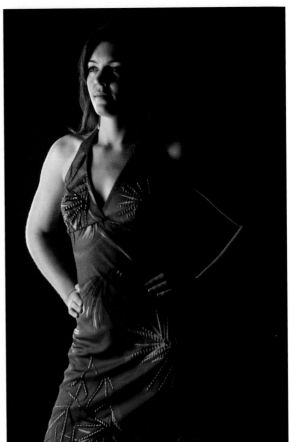

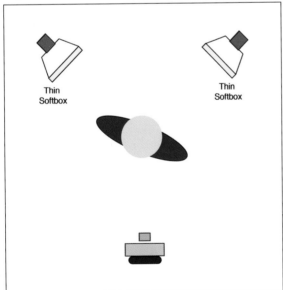

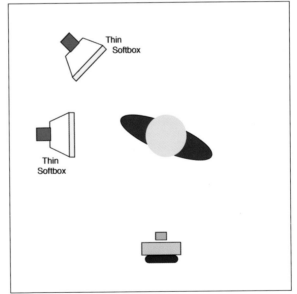

Two thin vertical softboxes are placed in the back corners of the set and aimed at the subject. This light creates highlights around the subject's body that ensure her separation from the background.

A thin vertical softbox on a large studio stand is positioned at the left of the set. The light is at a 90-degree angle to the subject. Another thin vertical softbox is placed in the back-left corner and aimed at the subject.

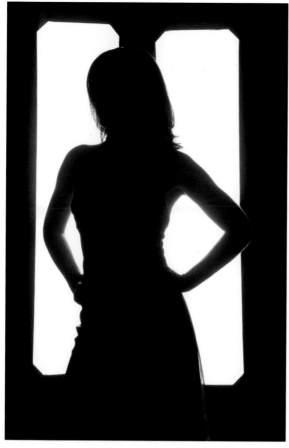

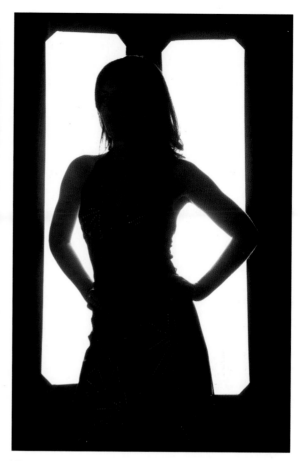

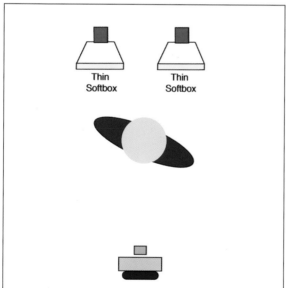

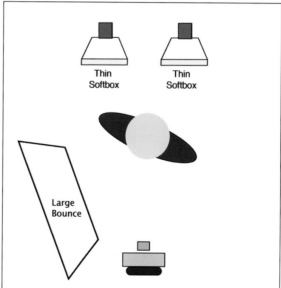

Two thin vertical softboxes are placed directly behind the subject and aimed toward the camera. This light creates highlights around the subject that ensure her separation from the background. This lighting setup creates intense flare and silhouette.

Two thin vertical softboxes are placed in the back corners and are aimed at the subject. They create highlights around the subject that ensure her separation from the background. The setup also creates intense flare and silhouette. A 6-foot tall white bounce card is positioned in the front-left corner of the set at a 45-degree angle. It reflects light back into the subject, adding more detail to the face and body.

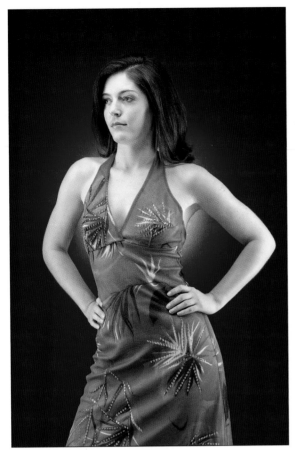

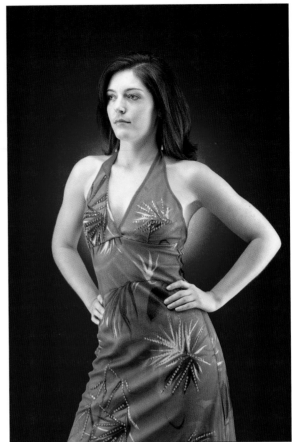

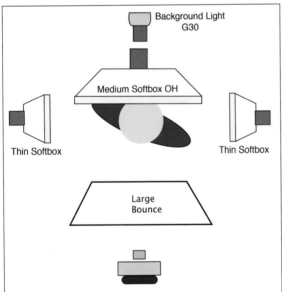

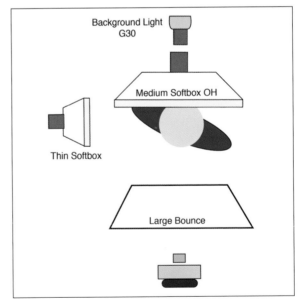

A medium softbox on a large studio boom stand is positioned above the subject. The light is at a 90-degree angle to the subject and about 3 feet away. Thin vertical softboxes are placed on the right and left sides 90 degrees to the subject. A large bounce card is placed between the camera and the subject and aimed upward toward the subject's face and body. This bounce card adds fill light to the subject's face and body. A strobe fitted with a 30-degree honeycomb grid is aimed at the background. This creates a halo effect in the shot.

A medium softbox on a large studio boom stand is positioned above the subject. The light is at a 90-degree angle to the subject and about 3 feet away. A thin vertical softbox is placed on the left side of the set, 90 degrees to the subject. A large bounce card is placed between the camera and the subject and aimed upward toward the model. This bounce card adds fill light to the subject's face and body. A strobe is fitted with a 30-degree honeycomb grid and is aimed at the background. This creates a halo effect in the shot.

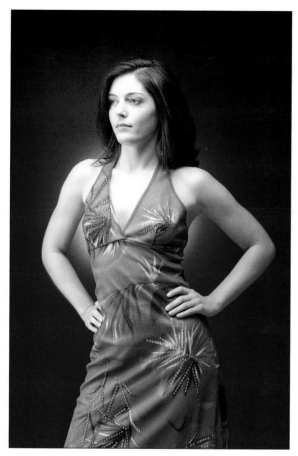

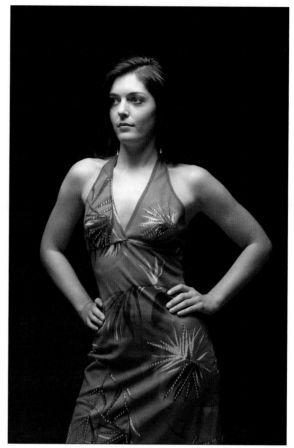

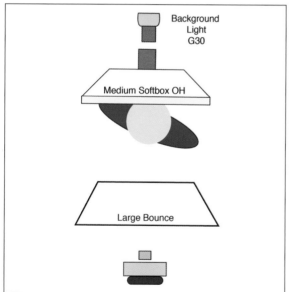

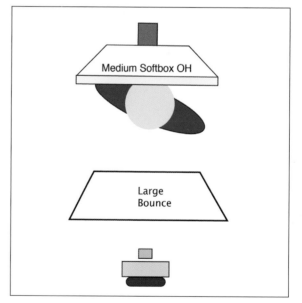

A medium softbox on a large studio boom stand is positioned above the subject. The light is at a 90-degree angle to the subject and about 3 feet away. A large bounce card is placed between the camera and the subject and aimed upward toward the model. This bounce card adds fill light to the subject's face and body. A strobe fitted with a 30-degree honeycomb grid is aimed at the background. This creates a halo effect in the shot.

A medium softbox on a large studio boom stand is positioned above the subject. The light is at a 90-degree angle to the subject and about 3 feet away. A large bounce card is placed between the camera and the subject and aimed upward toward the subject's face and body. This bounce card adds fill light to the subject's face and body.

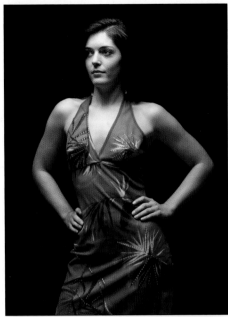

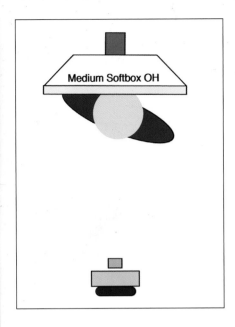

A medium softbox on a large studio boom stand is positioned above the subject. The light is at a 90-degree angle to the subject and about 3 feet away.

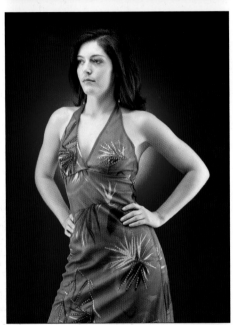

As you can see, the final two photographs on this page are completely different. The only thing that has changed is the way the light was cast onto the model. To create the top image, we used several lights to highlight every part of the model and enhance the set. The green dress is vibrant, her hair is backlit, and her skin is evenly lit. A bounce card was used to soften the shadows, and the separation between the model and the background is extreme. This is a beautifully executed portrait.

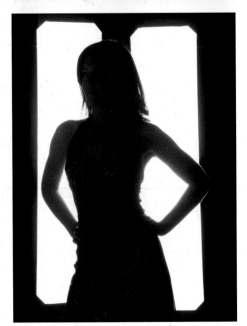

The portrait at the bottom of the page is also beautifully executed, but it is completely different. Because the lights are shining directly into the lens, the model's face and body are silhouetted, and the color of the dress is muted. The bounce card only adds detail to the model's features. The background appears light, and the foreground is a dark shape with little detail to enhance the viewer's perception of the image.

Portraits are a great way for a photographer to express themselves artistically. When you have produced an artistic portrait, your client will appreciate what you have done, and your reputation will soar. At the very end of a photo shoot, it is important to understand that the camera, the subject, the set, and the amount of money spent did not create the feel of the image. It was the light used to enhance the model and the set. Professional photography is about light, and good lighting comes down to careful placement.

Part 3.
The Creative Approach

In this section, I will present techniques I have used to create an effective, believable rendition of a variety of subjects. Note that while some components of a setup might be similar from one type of shot to the next, the result of applying various techniques can vary widely from subject to subject and will promote a certain mood in the final image. I have used every one of the lighting techniques described from here on in to produce images for paying clients—and you can use them as a springboard for your own commercial lighting ventures.

Casual Light

The goal in creating a casual style of light is to accent ambient light and make the viewer believe that no light was added to the scene. The trick is to add light in a way that appears natural. For example, if you are shooting a beach ball, place a strong light high above the ball. If you are creating an image that appears to be illuminated by lamp light, shoot a light warmed with an amber gel through a lamp shade.

The casual lighting approach works well when photographing models outdoors. Using portable, battery-operated light units, you can add a little light and fill in shadow areas. Test out your flash at several exposure settings. This way, you can choose the best light. Also, be sure to carry extra batteries with you for a shoot like this. Nothing looks less professional than running out of juice!

Make sure the model feels safe and is comfortable in her pose. Even though we were on railroad tracks when this image was created, we were positive that a train was not coming—and that the tracks were not too hot. The makeup artist was on hand to ensure that, should the model start to sweat, her makeup would remain intact.

To get the best-possible feeling from your models, they must like you and trust that the photos you are creating are good. I usually share the images with the models during the shoot. This way, they can share their input. You and the model are working together to get the best-possible image. If you don't communicate with her, she could clam up and become difficult to work with.

Note that creating casual light for a product in the studio can be more difficult. To supplement the lighting, you must first examine the way the existing light reflects off of the product, then you must find a way to emulate that effect.

About the Image. Imagine the sun on a cool autumn day. The sun up in the sky is warming the planet just enough so that you can wear shorts—but when the sun begins to drop, the slight chill of fall sets in. For a portion of the day, you are shooting a model's portfolio. Do you want to capture the feel of the day? Do you want your image to convey a colder or warmer day?

For this image, I decided to embrace a casual, soft look that evokes the feeling of a late summer or early fall. The sun was behind the model, and on-camera flash was used to add fill to her face and body. It's a good idea to keep the sun behind the model's head and body when possible. This makes it easier to add flash to fill in the shadows created by the sun.

I used the line from the railroad tracks to enhance the feeling of depth in the image. The aperture allowed for me to blur the background and focus the viewer's attention on the subject.

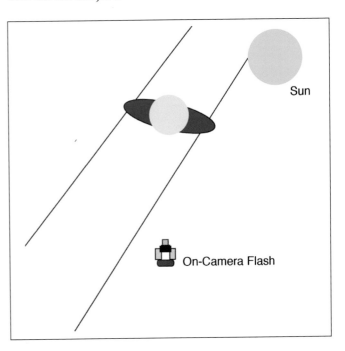

Tools: Olympus e500, Minolta 2800 AF flash, 14–45mm lens
Lights: sun, on-camera flash
Power settings: n/a
Camera settings: shutter speed 1/60, aperture f/8.0
Who's on set: photographer, assistant, model, makeup artist

Dramatic light tends to create a fine-art feel, presenting objects in a way that is different from the way the human eye normally perceives them. It is used to show off a subject's features or hide its flaws and, by its nature, can lend a little zing to a boring subject. By using wisps of color and contrast, you can create images that appear to come straight out of fantasy novels.

People are used to seeing the world with light coming from overhead. By narrowing the field of light or bringing it in from another direction, you can force viewers to see the subject differently. You can create a dramatic lighting scenario by understanding the rules of lighting, then breaking them for effect. Of course, simply breaking the rules does not ensure that you will create light that enhances the image. To successfully create dramatic light, two things must happen: it must look out of the ordinary, and the effect must look great. Remember, we are working on lighting techniques that make money, not techniques that don't work.

To successfully create dramatic light, you must create dramatic shadows as well. The materials needed to create a dramatic look are inexpensive. You can place a cookie in front of a light to create your shadows. A mirror can be used to cast light back into the scene to soften the shadow areas. With black foil, you can create modeled or formed shadows that complement the composition. Take care to preserve shadows that contribute to the overall look and feel of the final image. Shadows can make or break the image—and the photo shoot.

As a professional photographer, you should be able to control all the lighting elements to create a perfect product. Nothing happens by accident—at least, that is what we tell the client.

Determining when to use dramatic light will become second nature to you. With experience you will learn to read the client's wishes and determine whether they want a dramatic image or just a powerful one.

About the Image. To produce this image, I placed a panel to camera left and parallel with the set. A Speedotron light was positioned in the upper-left of the panel, or the P2 position. This light was on 50 percent power. A bottom bounce card was added in front of the subject and a second bounce card was placed to the right of the subject to reflect the main light back into the set.

When using messy materials for props, protect all of your equipment. Cocoa powder is very messy, so I used plastic sheets to cover my lighting gear and the floor. I also had wet wipes next to the camera so that if I needed to touch the model's hands, I could quickly wipe the cocoa powder from my own hands before I touched my camera or computer again.

Keeping the light soft helped me capture this image. The depth of field for the shot was strong in the original exposure. This allowed me to control focus later in the computer. Using Photoshop, I created a new layer, added the Gaussian blur, and merged the two layers to achieve the feel of a controlled lack of focus. Softening the subject produced a feeling of calm in the image.

I usually shoot for full focus and allow room to crop on every image. This way, things that can't be fixed on the set can be fixed in postproduction.

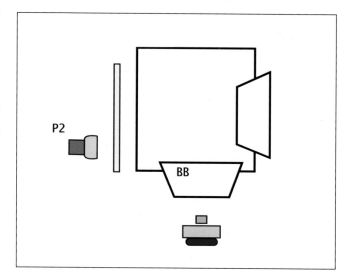

Tools: Mamiya 645AF, 80mm lens
Lights: Speedotron 2400 pack, panel with a Speedotron light in the P2 position, bottom bounce, side bounce
Power settings: main light at 50 percent
Camera settings: shutter speed $\frac{1}{60}$, aperture f/4.5
Who's on set: photographer, assistant, model

Dappled Light

When an entire set will appear in a photograph, there are typically many set elements that help to create the mood. In such a case, two types of lighting come into play: precise subject lighting and atmospheric lighting.

We've covered a number of techniques for creating precise subject lighting. To create atmospheric lighting, you need to introduce light that produces separation between the subject and its backdrop. A variety of tools can be used to project shadows onto walls and into sets. However, I have found that using black foam core with holes cut into it is the best and least expensive way to dapple light. These forms can be placed in front of a light that is already being used on set.

Dappling light can also create the feeling that an object outside of the set (leaves or a window frame, for example) is casting a shadow. Use this to create the feeling that the shot is made in a home rather than a studio.

About the Image. A light is placed in the P1 position and shot through a panel. This is the main light. Next, a light fitted with a 30-degree honeycomb grid is used to light the background. A strobe fitted with a 20-degree honeycomb grid is used to create highlights in the middle of the shot. Using grids on these lights allowed for more control over the bright spots in the composition. A bottom bounce, top bounce, and side bounce are used to fill in shadow areas. Finally, a black card with oval-shaped holes in it is used to dapple the light from the grid and from the P1 light. This makes the set feel larger, less staged, and more like it's being lit by a window or candles.

When creating a shot that contains so many objects, clean every item on the set and make sure there are no fingerprints on the products. A little bit of cleaning now can reduce a whole lot of computer work later.

The composition of this image was guided by three things: the color of the objects, the size of the objects, and the way the light is hitting those objects. Keep your colors in the same palette if possible. Remember also that tall objects in the back of the shot can cast shadows or unwanted reflections into the set.

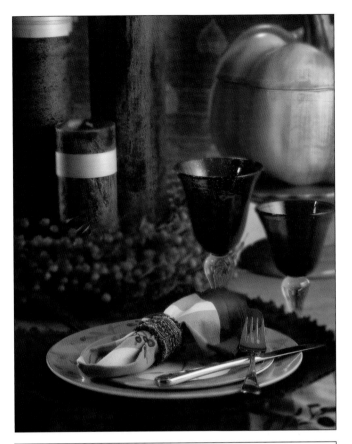

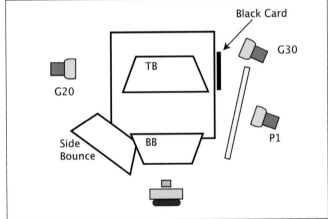

Tools: Mamiya 645AF, Phase One H5, 80mm lens
Lights: two Speedotron 2400 packs, strobe in the P1 position, light panel, 20-degree honeycomb grid, 30-degree honeycomb grid, top bounce, bottom bounce, side bounce, black card
Camera settings: shutter speed ⅟₃₀, aperture f/13.5
Power settings: P1 at full, G20 at 50 percent, G30 at 50 percent
Who's on set: photographer, assistant, client

The monotone look made this image a success. The model's bathing suit was a distracting color, her hair was brown, and the mats were black. Had it been presented in color, the image would have been a disaster.

When it comes to lighting for black & white, less is often more. Here, the model's skin tone is soft. To achieve the look, we aimed the softbox to the side of her, and the light came seeping out of the side of the box. A black card was placed in front of the softbox in order to control the spill from the rest of the softbox. Only one light was used on the left side of the model, and a bounce card was used to fill in the shadow detail on her right side.

To get the great backdrop in this image, I used three rubber bar mats. They were laid on a long board that was held up by two sawhorses. To get the lighting I desired for this portrait, the softbox was aimed just past the model instead of directly at her. The light was then bounced back in from the left side.

We were going to do this shot in color, but the bathing suit was a weird purple color that would not

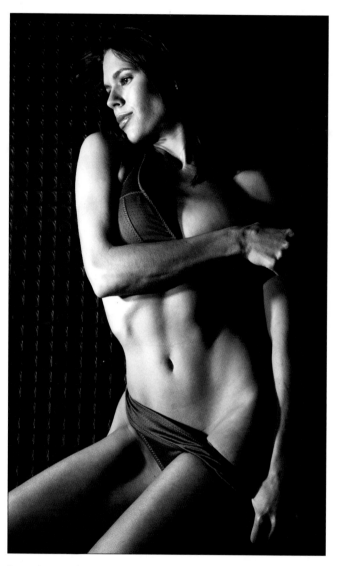

have been pleasing in the composition. This meant that to get the shot, we had to go with black & white. Never be afraid to offer black & white. Sometimes it is exactly what is needed to get the right shot for the job.

Gaining the trust of the model is important. I needed the model to feel comfortable exposing as much of her skin as needed to get this great shot. You can tell by the look on her face that she is not at all worried about her pose.

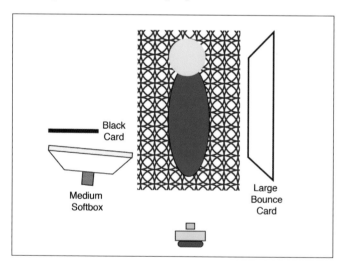

Tools: Mamiya 654AF, 80mm lens, stand, three rubber mats, two sawhorses, angled board
Power settings: full power
Lights: Speedotron 2400, Chimera medium softbox, Chimera 4x4-foot bounce panel, black card
Camera settings: shutter speed $\frac{1}{60}$, aperture f/16
Who's on set: photographer, assistant, model, makeup artist, client

Making Images Look Old

Making images look old can sometimes help create feelings of trust, good memories, or antiquity. Images like these are used in advertising every day. Knowing how and when to produce images that look old will help you and your client convince the public to buy what you're selling. Here are some tips:

1. Use dated materials and older subjects.
2. Dirt and scratches will only add to the shot.
3. Use hard light from the sides. Remember, diffusion panels are a modern photographic tool.
4. If shooting in color, try using warming gels on your lights. Yellow, orange, and amber gels can be useful.
5. Don't fill the shadow areas too much. Strong shadows will help create the feeling of an old photo. Light shadow areas create a more modern look.
6. Try adding a sepia tone to a black & white film image or use Photoshop to emulate the look.

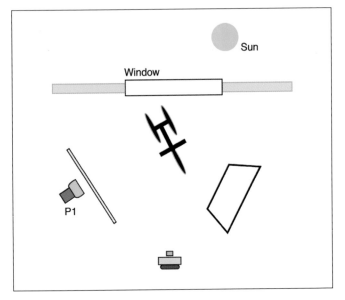

Tools: Mamiya RB67, Polaroid back, Tri-X black & white film, 120mm lens
Lights: panel with strobe in P1 position (main light), sunlight (fill), side bounce card
Power settings: P1 strobe at full power
Camera settings: manual mode, shutter speed ¹⁄₆₀, aperture f/16
Who's on set: photographer, assistant

About the Image. I selected an old building in which to create the shot. It was the perfect backdrop for the image of the tricycle. Instead of using my digital camera, I decided to shoot the image with film to achieve a grainy look that aids in creating the old-time feel. Though the plastic on the window is modern, its tattered appearance adds to the authentic feel of the image. The dusty, tattered wood floor adds to the image concept and creates a dynamic feel, and the position and constitution of the bucket add interest and helps the image visually come together. The long, dark shadows indicate that the image was shot later in the day and add to the nostalgic feel of the shot.

In this image, the strobe served as the main light. The sun did not shine directly through the window and served only as fill.

When shooting in black & white, look to the zone system. Having a solid understanding of the system will help you to make the best-possible exposure decisions.

There are infinite ways to light a portrait, but the light cast onto an interesting model should relate a visual message about the subject. The client-pleasing technique described below is simple to set up and produces elegant results. It can be used with any subject, from CEOs to family members.

About the Image. The lighting used in this portrait was simple, but adding additional lights would have affected the integrity of the shot. The model's face is perfectly lit, and the light shows her beautiful form to best effect. To produce the effect, we placed a softbox at camera left, aimed a softbox directly at the model's front. We used a bounce card, about 3x5 feet in size, opposite the softbox to fill in the shadow areas. A strobe

was aimed at the back wall, which was a good twenty feet away. This light helped to produce a feeling of depth in a portrait that was otherwise flat.

The pose and props combine to great effect in this portrait. I had the model turn slightly from the camera, push her camera-left hip out, and slightly pull the elastic on her panties to emphasize her curves and visually lengthen her body. Note that the hat serves two purposes in the image: First, it ensures a degree of modesty. Second, the deep shadows we created on its surface add a sense of depth and dimensionality in the image.

It's important to ensure that the model is comfortable with the pose you have in mind. Always maintain a professional demeanor and, if the model will be showing some skin, explain why you feel the concept is important. Also, never work alone with a topless model. Having someone else on the set can help to put the model at ease. In this case, there were several other people on the set, one of whom was the model's agent.

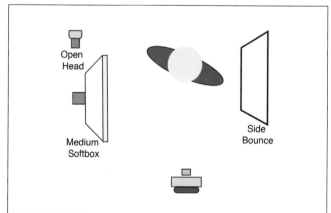

Tools: Mamiya 645AF, Phase One H5, 80mm lens
Lights: two Speedotron 2400 packs, strobe, medium softbox, side bounce
Power settings: softbox on low power, open head at ⅔ power
Camera settings: shutter speed ¹⁄₆₀, aperture f16
Who's on set: photographer, assistant, makeup artist, stylist, client, model, model's agent

Fashion Lighting

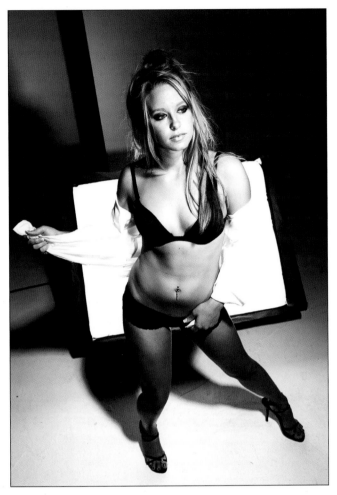

I take as much freedom as I can when lighting clothing and faces for fashion editorials. It's great because the only real rule is to show the clothes or model in an interesting light. That is easy enough. If your client is happy, you get paid and they call you for another job. That's proof that you've done your job well.

About the Image. I usually present the client, model, and assistant with a simple overview of the image concept. This puts everyone at ease before the shoot begins. Once the model is assured that she will look good, you'll gain her trust. When your client sees that you have the job under control, you'll have a happy client.

To create the image, we positioned our main light—a strobe fitted with a 20-degree honeycomb grid—on a boom above the model's head and directed the light

onto her face. A strobe fitted with a 30-degree honeycomb grid was also placed on a boom. This overhead light was directed at the model's body and served as our fill source. A softbox was placed on the floor and aimed upward toward the model and the camera. A side bounce was used to bounce the light from the softbox back toward the model and fill in the shadow side. I was able to achieve a higher camera angle by shooting from a ladder; this helped to make the model appear taller. Forcing perspective is a great trick when photographing a shorter model. The black & white tones helped to produce a glamourous mood in the image.

When photographing a model, her comfort with the shot is of utmost importance. In this case, the model's mother was stationed on the set to ensure that the session unfolded as planned.

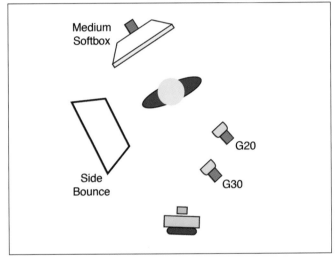

Tools: Mamiya 645AF, Phase One H5, 35mm lens, ladder
Lights: three Speedotron 2400 packs, strobe fitted with a 20-degree honeycomb grid, strobe fitted with a 30-degree honeycomb grid, softbox, side bounce
Power settings: strobe fitted with a 20-degree honeycomb grid at full power, strobe fitted with a 30-degree honeycomb grid at 75 percent power, softbox at 25 percent power
Camera settings: shutter speed $\frac{1}{60}$, aperture f/13.5
Who's on set: photographer, assistant, hairstylist, makeup artist, model, model's mother

Most corporations are looking for images that project confidence, power, and success. They also want portraits that promote trust. To create these feelings, you'll need to pull out all of the stops—and a variety of equipment.

Producing images that look clean and high tech can be a challenge, so it is important to establish a realistic budget before bidding. Let the art director know that good photography is not inexpensive. Using professional models and incredible locations may increase the cost, but you'll produce a top-notch product.

One successful approach requires that you create a bright background with lots of punch, then light the model or subject even brighter. Using flash from the front and below the subject gives the image clean separation from the background. Alternately, you can create a very dark image. Add a minimum of highlights to let the viewer know what they are looking at, but keep the rest of the image dark.

Camera angles are very expressive. By shooting from below with a wide-angle lens, you can make your subject look large and powerful. By shooting from above, you can promote the sense of trust and nothing to hide.

When photographing corporate heads, time is of the essence. With a nervous corporate personality who has little time, you may feel rushed to get the photo finished. Your best bet is to create the set, then use a sit-in model to get the light right. With everything in place, you can summon the subject and start the shoot.

Here are some additional tips for getting a great shot:

1. Avoid shadows that distort your subject's face. You want your subject to appear honest and successful, and like anyone could do business with them.
2. Act in a professional manner. You can crack a few jokes if that is your manner, but remember that the corporate environment is much different than the artistic environment of the average photo studio.

About the Image. The subject was positioned with the sun behind his back. The camera was positioned to the left of the set and, as mentioned above, the wide-angle lens was aimed slightly upward to make the subject appear more powerful. An umbrella, at full power, was used to fill in the shadows.

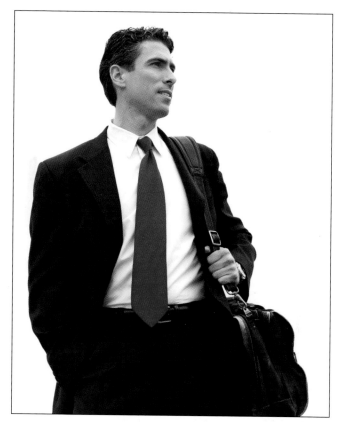

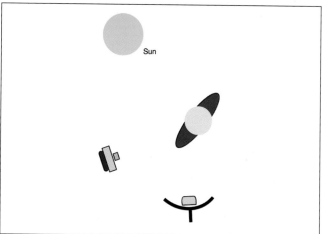

Tools: Mamiya 645AF, 50mm lens
Lights: Hensel Porty Kit, sun, umbrella
Power settings: full
Camera settings: shutter speed ¹⁄₆₀, aperture f/22
Who's on set: photographer, model, makeup artist

Lens Flare

Flare is the non–image forming light that is recorded by the camera. It can be caused by light that is directly hitting the lens or bouncing off a surface into the lens and can result in characteristic shapes and lines in the image.

Flare can also cause the colors in your image to look washed out. Sometimes you can tell immediately that you have flare in your image; other times, it's harder to tell. The trick is to know what color saturation to expect in your photograph. If the colors are washed out even a little, you could have lens flare. (*Tip:* You can boost the saturation of the darker colors in the shot in Photoshop. Simply go to Image>Adjustments>Levels and move the shadow slider under the histogram slightly toward the right.) Flare can also flatten the image contrast and just plain make the image harder to view.

The good news is, flare can be controlled using one of the following techniques.

1. When photographing a product on a light-colored surface, place black cards as close to the product as possible without infringing on the image frame. This will reduce reflection into the lens.
2. When light is hitting the lens, either move the light or find the source of the flare and place a black card between the light and the lens.
3. Try not to use bright colors when photographing a product that will be clipped out in Photoshop. The bright colors can affect the white balance of the scene, create a color cast, and even affect exposure. Use a darker neutral gray backdrop. Once the image is clipped out, the color of the paper won't matter—but the colors in your product will appear richer when photographed against a neutral backdrop.
4. Before you start shooting, wrap a long, thin piece of black paper around the lens. This will act as a compendium hood. It's cheap and it works. Just make sure that the paper doesn't cut into the image frame.
5. Place a square black piece of foam core on the front of your camera with a hole in it for the lens. This stops any unwanted reflections from the shiny parts of the camera.
6. Place black cards between your light and the camera at all times. It may seem as if you're being overly cautious, but it's better to be safe than sorry.

All of the above tips will help you keep flare at bay and create richer colors in your images. You will find that the control you have over light is indeed professional.

About the Image. For this shot, an umbrella placed about 45 degrees to camera left served as the main light. Two strobes were placed behind the subject and aimed directly at the camera lens.

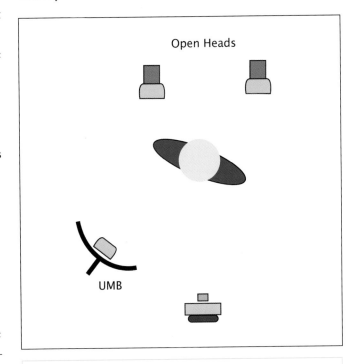

Tools: Mamiya 645AF, Phase One H5, 35mm lens
Lights: two Speedotron 2400 packs, three strobes, umbrella
Power settings: umbrella on full power, open heads at 50 percent power
Camera settings: shutter speed $\frac{1}{60}$, aperture f/11
Who's on set: photographer, model, model's friend, makeup artist

The Creative Use of Flare

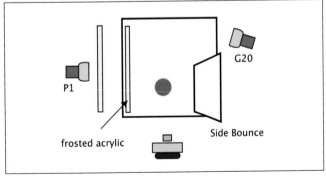

Tools: Mamiya 645AF, Phase One H5, 80mm lens
Lights: two Speedotron 2400 packs, strobe at P1 position, light panel, frosted acrylic, side bounce
Power settings: P1 light at full power, G20 at 50 percent power
Camera settings: shutter speed $^1/_{10}$, aperture f/8
Who's on set: photographer, assistant, client

To make flare work for you, you must find the middle ground of where the light is coming into the lens and washing out the background and the point where it enters the lens and enhances the shot. To do this, place your subject between you and the flaring light source, and let a little of the light peek around the subject. This is usually a quick fix for overwhelming flare, and it often helps create a pleasing overall look in the photo.

If you run into a more difficult situation, you can turn your main light up in power to allow for a smaller aperture setting, then turn your flare light down to minimize the light burst. By adjusting your main light, flare light, and aperture, you can create perfect glowing images.

About the Image. A panel was placed to the camera-left side of the table and a strobe was placed in the center (P1) position. An acrylic diffuser was placed between the product and the panel to further soften the light and create the straight white line on the side of the bottle.

A strobe fitted with a 20-degree honeycomb grid was angled toward the background. Next, a bounce card was placed directly across from the main light, creating the other white line across the length of the bottle. This adds a little something to the shot.

When creating a glow, a little goes a long way. We left the modeling lights on full power, fired the strobes, and dragged the shutters, allowing the light from the modeling lights to mix with the flash from the strobes and produce a little extra light to yield a pleasing glow. Here, the shutter speed was $^1/_{10}$ second; the longer the shutter remains open, the brighter the glow.

Note that the glowing light technique is different from the "daylight and tungsten together" technique (see page 118), though it may seem like splitting hairs. To me, this technique stops producing the effect illustrated above and becomes combined lighting when the image takes on a warm tint. If this happens, use your camera's gray balance feature to ensure that colors remain neutral.

In this image, the blue tint was added after the shoot using Adobe Photoshop.











Lighting Food

Lighting food can be a chore, but the following tips will help you to create the basis of a great shot.

1. When shooting meats and breads, use an overhead light with a soft amber gel as a fill. This will help create the feeling that the image is being shot in a kitchen or restaurant.
2. With grids or spots, highlight the Christmas ham, Thanksgiving turkey, or other hero of the set. You can warm these lights, but don't go overboard.
3. Use ample fill. Dark shadows take away from the visual flavor of food shots.
4. Use a soft main light above and in front of the food. Do not warm this light. For the best results, this light should be on its own power pack so you can control the power of your flash.
5. Place black cards where needed to create shadows. This is a great place to use dappled light.
6. Make the set accessible and safe for the food stylist, your client, and you. Otherwise, someone may trip, and a disastrous spill could result. Have ample towels and cleaning supplies on hand.
7. Keep the shot simple, and keep the viewer's focus on the foods that are most important to the meal. Avoid overstyling the shot and get in close to your main subject.
8. Use a short depth of field. This will give your image a clear focal point, but the rest of the image will appear blurred. This technique is flattering to many single plates of food and most drinks, especially when shooting from above the subject.
9. Avoid overlighting your subject. A single main source that produces an overall light plus an accent light that adds a little glimmer to the rearmost items is all that is needed most of the time.

There are several ways to photograph food, but with the tips above, you have the house built, and all you need to do is decorate. Don't be intimidated by your first food

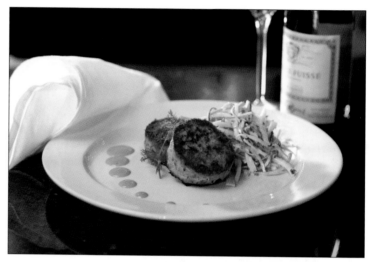

shots. Just remember that you are trying to create beautiful images with a certain "yummy" appeal. By using warm fill lights and a clean main light, you can create the visual atmosphere needed to make your client happy.

About the Image. The main light in this setup was an umbrella placed at the camera-left front corner of the set. A strobe fitted with a 30-degree grid spot was positioned toward the rear-left corner of the set; this produced a highlight on the food. A side bounce was placed opposite the gridded light to reflect the illumination back onto the subject.

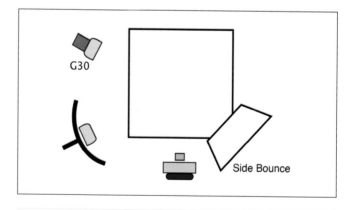

Tools: Mamiya 645AF, Phase One H5, 35mm lens
Lights: two strobes—one with umbrella, one with 30-degree honeycomb grid, two Hensel Porty packs, side bounce
Power settings: umbrella on 75 percent power, gridded light on 50 percent power
Camera settings: shutter speed $\frac{1}{30}$, aperture f/5.6
Who's on set: photographer, assistant, chef, art director

Lighting Rooms

In this section, you will learn how to control your light sources by equalizing the ambient light in the room and adding highlights or changing the direction of the main light source. I will also show a few techniques for taking care of unwanted light that may be coming from a window or hallway. Remember, you are lighting the set to the best of your abilities when every light and shadow has been checked and approved.

As you look at the interior space, remember that although you are lighting an object that has depth, you are creating a flat, two-dimensional image of that room. Look at every angle as if it were in a painting. Your exposure is your paint brush. The shadows are the darker palette, showing depth and size of the objects in the scene to the viewer. The highlights are the image's features, the objects of beauty and importance, the "why" of the image. I have included several images that show these lighting theories at work.

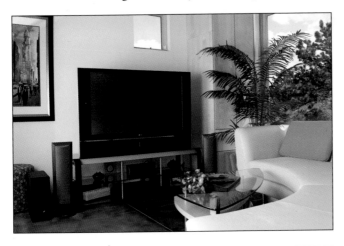

Though the interior shots shown in this section were made in rectangular rooms, remember that you will need to create images in interiors of a wide variety of sizes and shapes. Also, note that the lighting in a room changes as the sun moves around the globe. The sun is never in the same exact place twice in a year's time. Therefore, the approaches provided in this chapter should serve only as examples; your interior working space may require a different strategy.

The easiest way to light a room is to bounce your lights directly into the ceiling. This creates a soft, diffuse light that is usually complementary to the colors in the room. Also, it creates a natural-looking light source. Once you determine how many lights to bounce from the ceiling and where to place them, you can add fill lights to bring out the texture in the shadow areas.

Speaking of shadows, it's important to note that when lighting a room scene, there should be only one set of shadows projected from the objects in the room. Having several shadows cast to the sides of any objects is a sure sign that the room is illuminated by artificial light. Remember, you want the effect to appear natural.

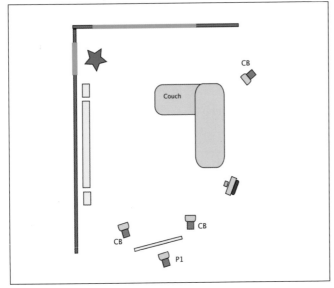

Please note that each lighting schematic deals with a particular problem and each technique can be used in any room at any time of the day.

About the Images. I always begin my room lighting job with ceiling bounces. To produce the first image

Tools: Mamiya 645AF, 80mm lens
Lights: three strobes bounced off of the ceiling, panel with light in the center, or P1, position
Power settings: ceiling bounce (camera right) at full power, two ceiling bounces at camera left at full power, panel with a strobe light in the center, or P1 position, at 50 percent power
Camera settings: shutter speed ¹⁄₃₀, aperture f/22
Who's on set: photographer, client, three assistants, stylist, set builder, product manager, art director, product coordinator

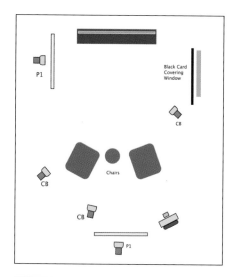

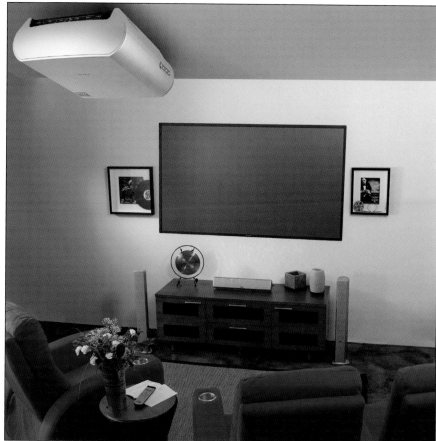

Tools: Mamiya 645AF, 35mm lens
Lights: three ceiling bounces, two panels with strobes at P1, black foam core
Power settings: three ceiling bounces at full power, strobe with panel at camera left at ½ power, strobe with panel at rear at ⅓ power
Camera settings: shutter speed ¹⁄₆₀, aperture f/22
Who's on set: stylist, photographer, two assistants, two clients, set designer

(facing page), I placed a ceiling bounce at full power on the camera-right rear area of the set. This served as the main light. With the light in position, I had to ensure that it did not produce a glare on the TV screen. Once this light was in place, I was able to determine that more light was needed on the far left side, so I added two ceiling bounces, which were used at full power. This reflected light throughout the room. These lights matched the light produced by the main light and the window.

Once these lights were set up, the console was darker than I wanted it. Because this was a commercial room shot, the TV and console needed to pop. Therefore, I added one final light: a panel with a strobe in the center, or P1, position. This light was at 50 percent power, but added to the effects of the other strobes, it produced a nice, bright light on the products. Because the light was diffuse, we were able to add brightness but still create a light quality that seemed to mesh with the light produced by the other units on the set.

This image, which was part of a series, was shot in an unfurnished house. We actually rented $30,000 worth

of furniture, artwork, and plants, and had it delivered to the location. We used Photoshop to doctor the unfinished areas of the home's walls and floors.

The lighting for the second image (above) was pretty straightforward. I started with the ceiling bounce on the right side of the camera, making sure the light stand was out of the view of the lens. I then placed the other two ceiling bounces toward camera left. The light from one was reflected from the ceiling onto the TV, and the other was bounced from the ceiling to the floor. All three strobes were on full power; they created the overall light in the room. Next, I covered the window with a piece of black foam core. Finally, two fill lights were added for atmosphere. The first—a panel with a strobe in the center, or P1, position—was added to the left side of the room and used at its lowest power setting. The second fill light was a panel with a strobe in the center, or P1, position. This light was placed at the left of the camera to provide fill on the back of the chairs.

This shot is an amazing example of photographic deception. If you take a good look at the "ceiling" in the

image, you may notice that it's actually an architectural feature of the house that drops down into the room. A little post-capture magic helped us to create this deception: the projector was shot separately and was added in Photoshop. Because the wall was only 10 feet wide but was 25 feet long, we created a little more wall area in Photoshop as well.

For the third room lighting example (below), we used an 8x4-foot panel with two strobes behind it as our main light. This light caused large shadows from the furniture to appear on the walls, so we added four strobes on boom stands—two pointed over the back wall and two pointed over the wall to camera left—to soften the shadows for a more pleasing result. This is a great technique for eliminating shadows while letting the main light do its work. Next, a large bounce card was used to reflect all of the light into the shot from the right side.

The strongest shadow in the shot is caused by the light inside the red and white table at camera right, which was used to open up the shadows of the hole of the table. Before the light was added, the darkness attracted the viewer's attention.

Fortunately, all of the shadows in the shot fall in the same direction. This adds credibility to any room shot.

Two exposures—one for the whites and one for the reds—were combined in Photoshop to produce the final image. The TV screen was originally just a solid blue, but a pleasing blue gradient seemed to add a little spark to the image. This once again proves that using Photoshop can allow you to creatively enhance your images, quickly and easily.

The set featured in this image was built and ready in one day.

Our fourth room lighting setup (facing page) bears some similarities to the previous setup we discussed. For this image, we once again used an 8x4-foot panel with two strobes behind it as the main light. In this setup, too, this produced large shadows. To soften the shadows on the tan wall, I positioned a strobe on a boom over the top of the wall and directed its light downward. Though the light made the top of the wall brighter, it did not affect the mood of the scene.

A panel was placed at the left side of the set with a strobe shooting through the bottom-left corner, or the P3 position. This light was used at a lower power than the other lights on the set. I wanted to create the effect that this light was coming from a hallway. By adding light to the tan wall, I was able to achieve more tonal difference between the tan and green wall. Also, the combined light from the three strobes really gave the wall a beautiful luminosity.

On the left side of the set, a large bounce card was used to reflect light back into the set. However, there was still not enough light to illuminate the wood grain on the entertainment cabinet, so another panel and

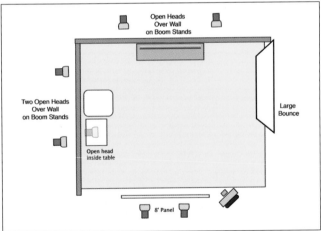

Tools: Mamiya 645AF, 35mm lens
Lights: four strobes on boom stands, 8-foot panel with two strobes
Power settings: strobes behind panels at full power, overhead lights at ⅔ power, light in table at low power
Camera settings: shutter speed 1/60, aperture f/22
Who's on set: photographer, client, two assistants, set builder, product manager

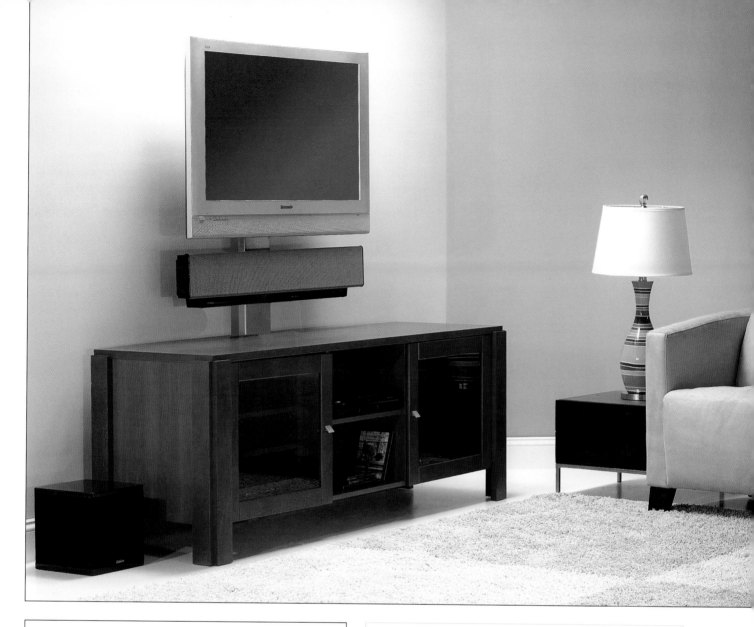

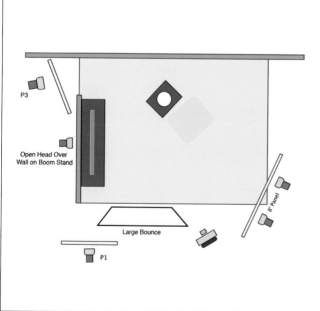

Tools: Mamiya 645AF, 35mm lens
Lights: large panel with two strobes, three panels with strobes
Power settings: 8-foot panel strobes at full power, P1 at ½ power, P3 on low power
Camera settings: shutter speed 1/60, aperture f/22
Who's on set: photographer, client, two assistants, set builder, product manager

strobe were added. We placed this light directly behind the bounce card to block this light from hitting anything other than the cabinet and speaker.

To produce the final image, I once again created two exposures, one for the highlights and one for the shadows, and combined them in Photoshop. The gradient on the screen was added in Photoshop too.

Once people are added to the mix, producing an effective room shot becomes more difficult. In our fifth example (next page), you can see that we have two mod-

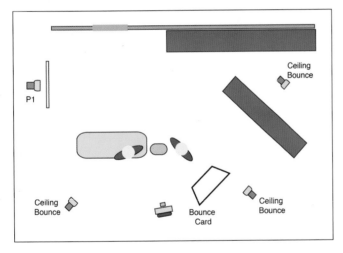

Tools: Mamiya 645 AF, 35mm lens
Lights: three strobes as ceiling bounces, one panel with strobe in center, or P1, position
Power settings: two strobes at full power, one strobe at 50 percent power, one strobe on lowest-available power setting
Camera settings: shutter speed $\frac{1}{125}$, aperture f/8
Who's on set: photographer, client, assistant, intern, stylist, product manager, two models

els, one product, fifteen reflective materials, overhead tungsten lights, and a window. In short, this scene was a lighting nightmare.

To light the shot, I placed two ceiling bounces at full power at the camera left and camera right front of the room. These co-main lights provided the required illumination in the front of the shot. There was a little light coming from the window in the background, but the back of the set needed more light. I added a panel with a strobe placed in the center, or P1, position at the rear camera-left area of the set. This light was used at 50 percent power and provided fill. This opened up the space.

Next, I had to focus my attention on the kitchen. I couldn't use lights placed outside of that area because the microwave was so reflective. I took an open head, layed it on the floor, and propped it up so that it was aimed at the ceiling. I choose to set the power at the lowest setting the power pack offered. This approach was certainly unconventional, but it did the job.

Though our final example (facing page) included a model and two extras, it was simple to light. There was

so much available light in the room from the large windows that all I really needed was fill light on the main subjects. The main light for the shot was a simple umbrella aimed directly at the boy. This light was at 75 percent power and was about ½ stop brighter than the natural light. This made the focal point of the image—the boy and his suitcase—pop right out of the shot. I added a light panel with a strobe at 25 percent power in the center, or P1, position behind the model behind the extras in the shot to produce a little fill. It was important to bring up the light levels in the areas behind the main subject to ensure that the image appeared natural.

Realism is important in commercial photography. If anything in the shot seems phony to viewers, they may not buy the concept or product you are trying to sell. On the other hand, there is a time and a place for playing upon the viewer's sense of disbelief. When you are trying to create a more fictional, fantastical image, go all of the way. Make sure that every aspect of the concept is simply and blatantly over the top.

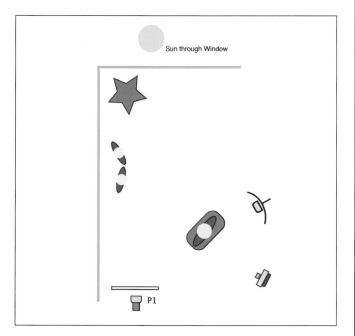

Sun through Window

P1

Tools: Mamiya 645 AF, 35mm lens
Lights: umbrella, panel, strobe
Power settings: umbrella at 75 percent power, panel with strobe at 75 percent power, in the center, or P1, position
Camera settings: shutter speed ¹/₁₂₅, aperture f/11
Who's on set: photographer, client, two assistants, makeup artist, child model and his mother, two extras

Lighting Automobiles

Photographing an automobile presents a unique set of challenges. There are chrome accents, the glass of the windshield, the plastics, rubbers, and fabrics, shimmering surfaces, and deep, dark holes to light. You'll also need to contend with mirrors and other reflective surfaces and wide-angle lens distortion. When creating interior shots, there is never enough room to bring all of your equipment into the cabin. To say the least, photographing the interior of an automobile is detail-driven work. Fortunately, the tips offered below will give you a head start.

Try to think of each car as an extremely fast work of art. Always remember to clean the surfaces you are photographing, and use bounce cards to finesse the light. A team of artists and engineers came together to create the automobile you are shooting; therefore, it's fair to say that a team of professional photographers can take a few hours to light the automobile and find the soul of its creators. The end image should be the culmination of your entire team's efforts.

I have illustrated this section with samples of my published work to point out that there is a demand for photographers who can accurately take pictures of the interior and exterior of automobiles. There are thousands of automobile collectors and enthusiasts who trick out their cars and want photographs.

Exteriors. When shooting the exterior of an automobile, you must use bigger light sources to illuminate the large areas involved. Auto exteriors are sleek and smooth with both large and small curves. The light you cast will either wrap around these curves or quickly get stuck in them and cause problematic reflections. Lighting a car requires constant finessing of the sources as you produce the reflections you want and eliminate the ones you don't want.

To create the image below, a coved wall was painted blue to match the stripe on the Ford GT. The main challenge in this shoot was lighting the car in such a way so as to not allow the blue in the set to show up on the

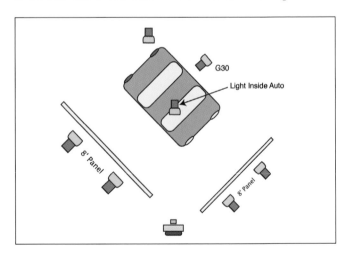

Tools: Mamiya 645AF, 35mm lens
Lights: three Speedotron 2400 packs, seven strobes (one with a 30-degree honeycomb grid), two panels, Hensel Porty pack
Power settings: strobes behind panels and open head behind car at full power, strobe in car at $\frac{1}{8}$ power, G30 at $\frac{1}{2}$ power
Camera settings: shutter speed $\frac{1}{15}$, aperture f/22
Who's on set: photographer, set builder, assistant, car owner

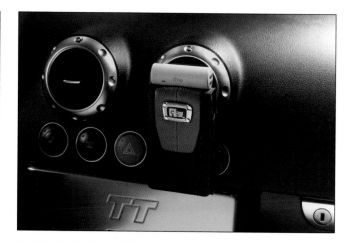

Auto Shoot Checklist	
Armor All	toothbrush
window cleaner	Play-Doh
leather cleaner	lighting grids
paper towels	lens cloth
vacuum cleaner	cotton gloves
museum putty	boom stands
bounce cards of all sizes	assistant
small mirrors	a flexible spine (you'll be in
bucket	some contorted positions!)
wash rags	

automobile's surface. This was accomplished by choosing an appropriate camera angle at the start.

I placed an 8-foot panel at the front of the auto and another at the passenger side of the car. Two strobes were placed behind each of the panels, one at each end at mid-panel height. These provided the main light in the image.

A strobe fitted with a 30-degree honeycomb grid was placed on the floor and aimed at the coved wall. A second light, powered by a battery pack, was placed inside the auto. It was fitted with an amber gel to create the color effect inside the cabin.

The final light was placed behind the auto and aimed at the floor, casting light under the car and toward the camera. This eliminated shadows and made the car seem to hover. It also created an intense highlight in the painted cove.

Interiors. Photographing the interior of an automobile requires a different but equally detailed approach.

For this example (right), we placed a 4x4-foot light panel on the dashboard, and the strobe was placed at the P1 position, shooting directly through the panel into the auto. To prevent scratching the hood, rags were placed between the light and the car's surface. Using a light stand, a second panel was placed outside of the driver's side window, and the strobe was also placed in the P1 position. These two lights combined to provide the main source of illumination on the dashboard.

Next, a large bounce card was placed in the front seat to help even out the light by reflecting the illumination provided by the two panels. Another bounce card was placed inside the driver's side door panel, bringing in even more lighting. These cards fill in areas that would otherwise go very dark. You don't want dark areas in

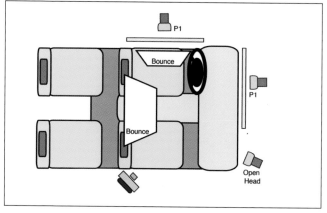

Tools: Mamiya 645AF, 35mm lens
Lights: open head, bounce cards, panel with strobe in center, or P1, position; panel with strobe in the center, or P1, position
Power settings: P1 through windshield at full power, open head at ¾ power, P1 on driver's side at ⅓ power
Camera settings: shutter speed ¹⁄₃₀, aperture f/22
Who's on set: photographer, assistant, client

your scene to force you to accept either losing detail or overexposing your highlights.

To produce specular highlights (small, bright points of light reflected from shiny areas of a subject), a strobe was aimed through the windshield at the bounce card in the seat.

In the second interior example (page 96, left), we see how to photograph the dash and the passenger's front seat. The setup is similar to the previous shot.

To create this image, the first light panel was, again, placed on the windshield, and the second was placed at the passenger-side window. In both cases, the open reflector head was placed in the center, or P1, position.

Next, I placed a large bounce card in the back seat. This reflected the light coming through the windshield

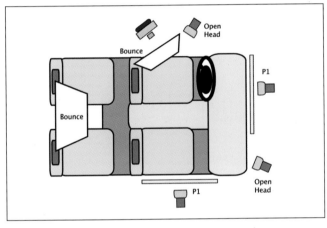

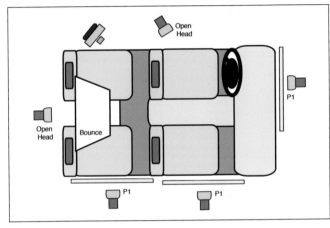

Tools: Mamiya 645AF, 35mm lens
Lights: two open heads, two panels with strobes in the P1, or center, position
Power settings: open head on driver's side on low power, P1 on windshield at ¾ power, open head on windshield at ½ power, P1 on passenger side on ½ power
Camera settings: shutter speed ¹⁄₁₂₅, aperture f/22
Who's on set: photographer, assistant, client

Tools: Mamiya 645AF, 35mm lens
Lights: two open heads, three panels with strobes in the center, or P1, position
Power settings: P1 at windshield at full power, panels with strobes in P1 positions at ½ power, open head at ¾ power
Camera settings: shutter speed ¹⁄₁₂₅, aperture f/22
Who's on set: photographer, assistant, client

back onto the dashboard. A second bounce card was placed inside the driver's side door, which was left open. Outside the car, an additional strobe head was then directed through the windshield and onto this card. This provides specular highlights on the interior, and a soft, bright fill for the entire front of the car.

Finally, another strobe was aimed through a panel on the driver's side of the car. This ensures that plenty of light is filling the interior. To control where this light from this unit falls, place this light on its own power pack and raise or lower the unit as needed.

The image was then shot from the open driver's side door.

For the top right image, we have a light panel on the hood with the strobe in the P1 position. We also have a light panel on the passenger side, in the same position as in the previous shot. A new panel with the strobe in the P1 position was added at the rear passenger-side window.

A bounce card placed in the back seat of the car is used to reflect light from an open head directed in through the back window.

The last light used in this setup is an open reflector shooting directly through the open window of the front driver's side door. This illuminates the front seats of the car and produces a feeling of direct sunlight.

The final image was shot through the rear passenger side window.

For the bottom-left image, we doubled the light coming through the windshield by using a longer panel and adding another open reflector head. Both lights are shining directly through the panel and into the interior of the automobile. The passenger side window is down, and an open reflector is placed outside it, adding the look of real sunlight on the front seat. The back passenger window is also lit, using a panel with a light in the P1 position. This evens out the exposure on any areas of the back seat that might fall within the camera's angle of view. On the driver's side, another open reflector shines into the back seat to add specular highlights.

The final image (bottom right) shows a perfect setup for creating a detailed shot of the front interior. The camera is inside the car and shooting over the top of a medium bounce card. This assures good fill within the camera's angle of view.

Outside the car, there are two lights on each side. On the passenger side, one open head skims directly across the dashboard. Another open head, placed in the P4 position, shoots at an angle through a diffused panel placed slightly to the rear of the first light. This adds diffused light and specular highlights from the passenger side. The same setup is mirrored on the driver's side of the car.

This lighting strategy produces the feel of natural sunlight as well as a great way to control the exposure in your shot.

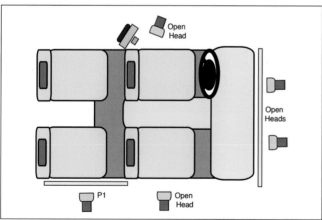

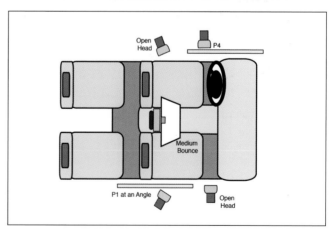

Tools: Mamiya 645AF, 35mm lens
Lights: two heads shot through a large light panel, two open heads, panel with strobe at center, or P1, position
Power settings: windshield strobes at full power, passenger side lights at ½ power, driver's side strobe on low power
Camera settings: shutter speed ¹⁄₆₀, aperture f/22
Who's on set: photographer, assistant, client

Tools: Mamiya 645AF, 35mm lens
Lights: two open heads, angled strobe in center, or P1, position; strobe in the upper-right corner, or P4, position; bounce card
Power settings: both passenger-side lights on full power, strobes on driver's side at ½ power
Camera settings: shutter speed ¹⁄₆₀, aperture f/22
Who's on set: photographer, assistant, client

When you're lighting complex sets, you should always take into consideration the safety of all those working around you. A maze of cables strewn across the floor of your set will surely trip someone. Try to have your power packs in a safe place but close enough to reach from the camera station. If that isn't possible, get the help of an assistant who knows how to use them well and can take commands from you. Do not yell directives at your assistant; if the power packs are far away, use a two-way radio for communication.

About the Image. We faced a number of obstacles when shooting the image shown here: the texture of the chair was easily lost in exposure; the model's expression had to be seen; the TV screen was a big, white reflector that needed to be at the correct angle to the camera; the speakers were black with copper insets—another exposure challenge; and finally, we were working on location. Auggghhh!

When you're faced with problems like these, be sure to let the client know that there are certain challenges that come into play when working on a large set—but keep the extent of those problems to yourself. This can help your client relax as you work through the challenges and come up with a perfect exposure. In this case, that meant employing six lights. We'd started out with eight lights, but soon realized that two lights were creating cross shadows that were doing more harm than good.

Always stay on top of the project and consider every nuance of the set. In large sets, you'll often be faced with a variety of faces, textures, and reflections. Keep in mind that there is great money in high-end photography, and larger sets usually mean larger checks. Pull out all of the stops. Take the time to look at test shots. If you find yourself in a real fix, then simply take your exposure one light at a time, and don't panic. This approach may not be very scientific, but it's effective.

You'll note that some of the images in this book were tweaked in Photoshop. My goal in sharing this image is to show how good a raw image can look without a lot of postproduction work. In this image, the digital finessing was minimal: the wall behind the TV was added.

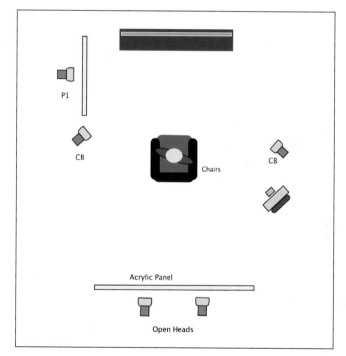

Tools: Mamiya 645AF, 35m lens
Lights: two ceiling bounces, panel with strobe in the P1 position, two open heads shot through an acrylic panel
Power settings: P1 left side on $\frac{1}{2}$ power, open heads behind acrylic panel on full power, CBs on $\frac{3}{4}$ power
Camera settings: shutter speed $\frac{1}{60}$, aperture f/16
Who's on set: photographer, assistant, client

Lighting Liquids

When photographing water, you must first consider the problem of working with two incompatible elements—water and electricity. (The two get along so well, it's shocking!)

When building a set for such a subject, make sure that you safeguard all of your equipment from spills or splashes. I create a safety barrier around my equipment using plastic bags and plastic sheets, and taping them down around the seams with gray duct tape. While this may make accessing your power packs more difficult, you don't want to get a single drop of water on your equipment.

Also, never do a pour shot alone. Always have the assistant pour the water while you take the shot. Use tubs to catch and contain the water, and keep a few towels on hand to ensure a quick clean up should the need arise.

About the Image. Splash shots are a lot of fun to photograph, and when done correctly, they make a great addition to your portfolio. Use a fast shutter speed and keep the duration of the flash as brief as you can. The

faster the flash reaches its maximum brightness, the better you will freeze the splashing water (or any other moving subject, for that matter).

We bored a hole into the back of a bar of soap and glued it onto a small boom stand, then extended the arm to the center of the set.

Because we planned to pour water over the soap, we placed a large tub on top of our product table and placed a milk crate inside of it, bottom up, so that the crate's surface would spread out the water, diminishing the force with which it hit the bottom of the tub and splashed upward.

We ended up flipping the shot upside down in post-production so the flush of water would appear more extreme from the top in the final image.

The final image shown is the result of combining three shots in Photoshop. We seamed together two shots to show the best-possible splash at the top and bottom of the soap. It was difficult to expose the white soap in the moving water. To produce the best exposure and the greatest amount of detail possible, we took a few shots of the product before pouring the water and then used the "dry" logo in the composite. This image is a great example of the lengths photographers will go to in order to get a perfect shot. It's a good idea to be generous when composing the image; extra space in the composition can easily be cropped out it postproduction, but you can't add water to your shot during the image editing phase.

Three lights were used in the setup. First, a strobe fitted with a 10-degree honeycomb grid was used to light the front of the soap. This produced a nice, rounded effect. The second strobe, fitted with a 20-degree grid, produced the perfect light for the water. Finally, a strobe fitted with a 20-degree honeycomb grid and a blue gel was used to produce a nice round background light. Top and bottom bounce cards were used to fill in the shadows to maintain detail in those areas.

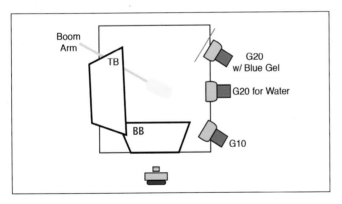

Tools: Mamiya 645AF, Phase One H5, 80mm lens, boom arm, tub, milk crate

Lights: two strobes with 20-degree honeycomb (one gelled), one strobe with 10-degree honeycomb grid, top bounce, bottom bounce

Power settings: strobe fitted with 10-degree honeycomb grid at 50 percent power, strobe fitted with 20-degree honeycomb grid directed at water at full power, gelled strobe fitted with 10-degree honeycomb grid at 75 percent power

Camera settings: shutter speed $^1/_{125}$, aperture f/22

Who's on set: photographer, assistant, client

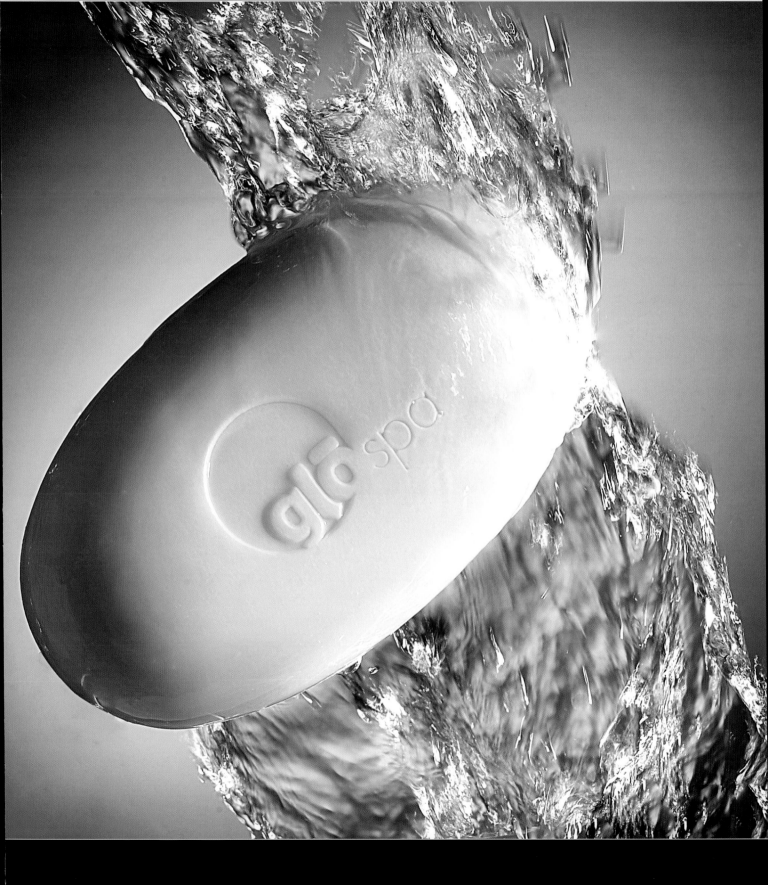

Lighting on Location

Lighting on location is the hardest but most rewarding thing a photographer can do. Having your clients ask you to work outside of your studio is a show of trust in your photographic abilities, so don't let them down.

Shooting on location is simplified with a great checklist. Your list should include directions to the location, the phone numbers for everyone involved in the shot, and all the equipment needed to complete the project. Forgetting a major piece of equipment can cause you a great deal of stress; if you've ever had this experience, you probably already have a list.

Once you have arrived at the location, find the electrical outlets you need, examine the scene for lighting challenges, and then bring in the equipment. Leave what you don't need for lighting the particular scene nearby but not in the way. It is always helpful to establish a designated storage area so you and your assistant know where to find things.

Also, try to make yourself comfortable before you start shooting. My philosophy is to take over the premises. Remember that you are welcome on the set, and the client wants you to make the best-possible photographs. For a day, you are a little bit like a celebrity, so enjoy that privilege.

Try to keep lights to a minimum. Overlit scenes present a hazard and create ten times more work. If you are not using a light, have the assistant put it away.

This is the time to pull out the time-saving techniques you have been developing. Bounce light off walls, and light the main subject with a grid. Use simple fills for the scene. Use one light with an umbrella on your outdoor subject.

About the Image. My task for this image was to visually represent the idea that retirement home residents had plenty of stuff. This image was used with the tagline, "Don't send us gifts, send us money." With this in mind, I needed to come up with a concept that relied upon a little slapstick humor.

When shooting an ad, take your audience into consideration and also, consider the message you are being paid to send. Also, be sure to get model releases from the subjects. A simple, to-the-point release form can be used; you need not use legal jargon.

When I arrived at this location, I had an idea of how the client wanted the image to look, but the closet was so filled with stuff that it was hard to tell there was a closet. I suggested that they remove most of the stuff and place some of the items to the side and behind the subjects.

Four lights were used to create this shot. The three umbrellas were used to create a full, rounded lighting effect on the scene. The two umbrellas to camera right were used at a higher power to create the main source of light in the image. The gridded light at the camera-right back corner added small specular highlights on the models and other objects of interest.

This shot was a lot of fun to produce. Keep in mind that it's okay to enjoy the shoot and have a good time. Just be sure that you do not lose control over your team, models, and client.

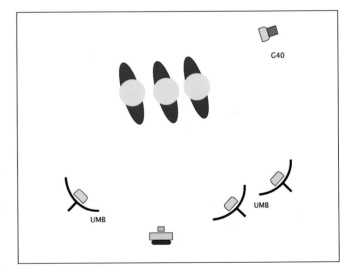

Tools: Mamiya 645AF, Phase One H5, 80mm lens
Lights: three Speedotron 2400 packs, three strobes with umbrellas, one strobe with 40-degree honeycomb grid
Power settings: left umbrella, 75 percent power; right umbrellas, full power; gridded light, 50 percent power
Camera settings: shutter speed 1/60, aperture f/16
Who's on set: photographer, assistant, art director, three models

Medical Light

Lighting for the medical fields should feel very different from other professional fields. Ads for medical procedures are only successful when the patient appears to be comfortable and at ease with the caretakers. When you light a scene with a patient and caretaker, you need to create a feeling of trust, care, and serenity. The subjects in the photograph project these feelings, but it is up to you to enhance these feelings with a pleasant, calming light. This is often accomplished by using a warmer light. Sometimes the image will need to look clean and cool—not sterile, but as close as possible. A cooler light is called for in such a case. In either scenario, you can achieve the desired effect by adding colored gels to your light source.

By understanding the use of the final image, you can determine the feel that the photo must convey. Just think about it for a minute: would you trust a hospital or clinic that was dark, dingy, and green? No way, and neither will your audience. When you are shooting, imagine that you are entering the space for the first time; think about the light that would most appeal to your senses, then create the image.

The following tips can help you achieve the best-possible images:

1. When lighting an exam room, bounce your main light into the ceiling. This give the feeling of general overhead light.
2. To make something seem modern or high tech, use blue, green, or pink gels. Try not to use red gels with medical equipment.
3. Keep medical scenes clear of clutter.
4. In the sterile environment of a hospital, clinic, or care facility, it can be difficult to create interesting shots. To improve your odds, try to close in on the subject. Many of the procedures done in these care facilities are interesting up close and personal.
5. When photographing an entire room, see if you can include plants or a warm color in the shot. This gives the viewer something less medical to view.

Working with Elderly or Disabled Models. Do not shy away from a model with a health condition. You do not want to make the subject feel weak or self-conscious. Too much sympathy can ruin the results of the photo shoot.

Work as fast as you can when shooting in a care facility. Many models with health conditions become tired easily. (Conversely, be aware that some models may not be able to work at a quick pace. Be sensitive, and don't make them feel as if they are slowing the process down.) Be precise, and make your decisions count. To ensure your model's comfort, you may also want to keep some water and food with you. Your subject's comfort is essential to a good outcome.

Also, you never know when an emergency will arise, leaving you and your equipment sprawled about and in the way. Try to keep your equipment close to you and accounted for. Make sure there are no cables where someone can trip over them. When taking the photo, prepare everyone for the flash. If possible, set the flash

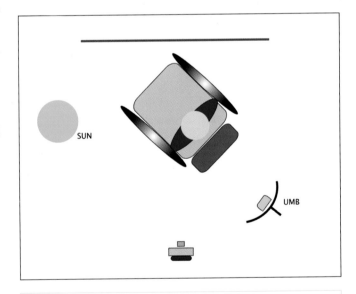

Tools: Mamiya 645AF, Phase One H5, Hensel Porty Pack, 80mm lens
Lights: strobe with umbrella
Power settings: umbrella on full power, sunlight
Camera settings: shutter speed ¹/₆₀, aperture f/22
Who's on set: photographer, assistant, art director, model

off a few times so the subject knows what to expect. Be sure not to scare anyone who has health problems.

In hospitals, the rooms are designed for the patient's comfort and ease of use, not for photographers. The ceilings are not very high. This makes these rooms hard to light because there are no angles for you to sneak lights into. Also, there are often ugly windows in the room. Many times you must light the room from the front.

As in all shooting circumstances, you must take charge and control the flow of the shoot. Without this control, you and the team can lose focus. When on location in a hospital, it can be a little harder to have fun as you might when the mood is a little lighter. The best thing to do is be kind, stay focused, remain professional, and remind yourself and your crew that you are there to do a job.

Final Tips. When shooting product shots for medical devices, you must convey to the viewers that the products are reliable and will simplify their lives or improve their lifestyle. Make sure that the ad sends a message that the product is good and safe.

Finally, test out the products and work only for companies that produce quality products. You don't want your name associated with a product that is ultimately the center of a lawsuit.

About the Image. To light this image, we placed an umbrella toward the front camera-right area of the set, about three feet from the subject. It was used at full power to overpower the sunlight. The sun, coming from the left of the subject, served as a fill light and produced detail and glimmer in all the right areas.

Scientific Light

Scientific clients want their images to look clean and modern. To do this, you can add extreme white light all around the main subject and enhance the background with gelled lights. You can also create arcs of light with grids and spotlights—or use both techniques at once.

When photographing scientists, you may be faced with a person who is on a tight schedule and not as photogenic as your hired models. In this case, remember that the proper light can make anyone look appealing. Try to use minimal light to get the shot. Often, you can bounce light off the wall to diffuse it; this saves you the time of setting up a softbox. If you want the scene to look like the light is coming from an overhead source, bounce the light into the ceiling and add an amber gel.

When working in a scientific campus, you'll want to have an array of lenses for shooting everything from whole rooms to extreme close-ups. Many labs have tight working spaces that are hard to photograph; consider wider lenses for these shots. With longer lenses, you can create focal effects using your depth-of-field settings.

If possible, have an assistant you know and trust on hand to help you move your equipment. By the time you have photographed everything from the labs to the CEO, you will be tired. Without an assistant, you may be exhausted and still not have the project complete.

About the Images. The product shown below was on the assembly line when we shot it. We zoomed in and used bright light to make it appear modern and clean. Of course, bright light can also be used to hide flaws and bring out the shape of an object, which we did here. Remember to control the brightness using your f-stop. Your RGB values for white should not exceed 250; if they do, you'll risk blown-out highlights.

To light the image, we first placed a strobe fitted with a 10-degree honeycomb grid at the back-left corner of

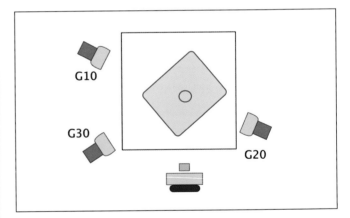

Tools: Mamiya 645AF, Phase One H5, 35mm lens
Lights: two Speedotron 2400 packs, 10-degree honeycomb grid, 30-degree honeycomb grid, 20-degree honeycomb grid
Power settings: strobes with 10- and 20-degree honeycomb grids were on a single power pack, and at 75 percent power; strobe fitted with 30-degree honeycomb grid at full power
Camera settings: shutter speed $\frac{1}{60}$, aperture f/11
Who's on set: photographer, assistant, art director

the set, then added a strobe fitted with a 20-degree honeycomb grid directly opposite that light on the camera-right side of the product. By pointing the lights at each other, we produced a beam of light that crossed through the center of the product. A third strobe, fitted with a 30-degree honeycomb grid, was added at the camera-left front corner of the shot and aimed at the middle of the product. The beam of light it produced crossed the first beam of light and created a controlled bright area in the center of the product. This is a great way to produce a foreground and background light that is convincing to the viewer.

Scientific product lighting can be tricky, but it is rewarding. The challenges that you may encounter vary from glass products to laser beams to the smallest micro-processor you have ever seen. What you do when faced with these challenges is up to you. I try to be creative and have as much fun as I can. Here are some final tips:

1. On location, bring cleansers and paper towels.
2. Find out what you can and can't touch before beginning work.
3. Go to the location prior to the shoot to investigate the lighting challenges.

Many scientific products are highly reflective. To produce the second example (right), we chose a camera angle that reduced reflection and ensured the correct framing. I wanted to keep the composition simple to produce a high-tech feel in the image.

A factory worker served as a model, and I took care to let the person know what we were doing every step of the way. If you can keep your subject connected with the shoot, you're likely to have better results.

To light the image, we added a panel to the camera-left side of the set. A strobe was positioned in the center of the panel, or P1 position. A second panel was positioned at the back of the set, and a strobe was positioned in the bottom-left corner, or the P3 position. A side bounce was positioned opposite the P1 light. White gloves can be difficult to light, so we had to check to make sure that our whites held detail.

The blue coloration, reflective materials, and white gloves in the image combined to create a sterile, high-

tech feel. We used a can of compressed air to clear any specs of dust off of the product before each and every shot we made to ensure a professional look.

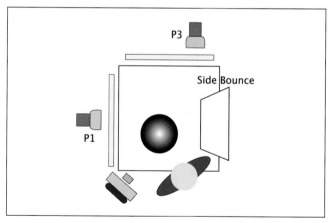

Tools: Mamiya 645AF, Phase One H5, 80mm lens
Lights: two Speedotron 2400 packs, panel with light at P1 position, panel with light at P3 position, side bounce
Power settings: P1 on high power, P3 on low power for fill
Camera settings: shutter speed $\frac{1}{60}$, aperture f/4.5
Who's on set: photographer, assistant, two clients, model

Overhead Light, Part 1

There are many things to be considered when lighting subjects. How will the photo be used? Does the art director want to clip the subject out from the background in Photoshop? What size image will be printed? What material is the subject made of? What will the background be? What camera angle will be used? Once you have answered the above questions, you are free to light the subject.

The lighting diagram and the paragraphs that follow describe the simplest way to light any subject—whether people or products. The technique is fast and efficient and is the basis of other, more complicated techniques.

For this technique to work, ensure that the subject is in the center of the set. Changing the subject or lighting placement shown in the diagram can negatively impact the resulting image. Also, for the best-possible results, avoid overlighting your subject. Remember, simple lighting is not easy lighting.

About the Images. Photographing the natural lines of the flower was a welcome change in pace for me. To ensure the best-possible image, I examined the flower from many angles and found that this presentation produced the best effect. I misted the flower with water to produce a fresh-picked look, and decided on a tight composition and simple lighting setup. In some cases, simple is best. Often, the simplest lighting setups produce the most unusual and effective lighting nuances.

Many shots start with a light placed above the subject. Here, we placed a panel on a boom stand and aimed the strobe at the flower from the P1 position. Remember that light that comes primarily from above appears natural to us, and light that appears to come from out of nowhere should be avoided. When using overhead light, you should take care not to overlight the subject. Bounce cards should be used to reflect light back into the subject to produce a balanced lighting effect. Here, side bounce cards placed to the left and

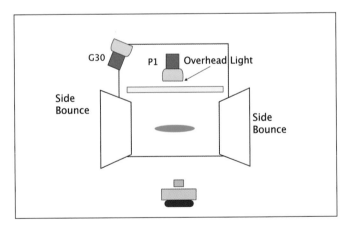

Tools: Mamiya 645AF, 80mm lens, Phase One H5, two side bounce panels
Lights: two Speedotron 2400 packs, two strobes, two side bounce panels
Power settings: overhead light at 75 percent power, backlight at 25 percent power
Camera settings: manual mode, shutter speed ¹⁄₆₀, aperture f/22
Who's on set: photographer, assistant, art director

right sides of the flower produced the desired effect. We placed an A-clamp on one corner of each of the bounce cards; this acted as a makeshift stand and weight and kept the bounce cards in place.

To round out the lighting for this subject, a second strobe, fitted with a 30-degree grid spot, was aimed at the backdrop at the camera-left rear corner of the set.

The simple gray background chosen for this image allows the colors of the flower to pop. This enhances the image's impact on viewers.

Our second overhead lighting example is a portrait. To produce this image, a strobe fitted with a 30-degree honeycomb grid was mounted on a boom stand and positioned above the client. This served as the main light in the image. A strobe fitted with a 20-degree honeycomb grid was aimed at the subject from the camera left side of the set to provide a little pop. A bottom bounce was added to fill in the shadow areas of the model's face and produce detail in the darker tones.

Using a gridded overhead light can create a nice effect for portraits. When photographing a model, as opposed to a product, a new rule comes into play: you must ensure your subject's safety. Because our overhead lighting assembly weighed in at 75 pounds, we were sure to double check all of our tension settings, and we added weights at the base of the stand.

The creative aspects of your shot can have as great an impact on viewers as the technical elements. In this case, the hair, makeup, and clothing were specifically selected to work with this model, who was chosen from a group of several models being photographed that day. As you can see, her clothing is a bit out of the ordinary. It's okay to go crazy with an outfit every once in a while. There's no reason why you should not have fun as a professional photographer. Making creative images is what it's all about.

Tip: When photographing models wearing this much makeup, be sure that the makeup artist has applied enough translucent powder to eliminate any glare. Sweat can make the model's skin glisten, and that can easily ruin the shot. As you can see in this shot, there's a fine line between sweat and shine.

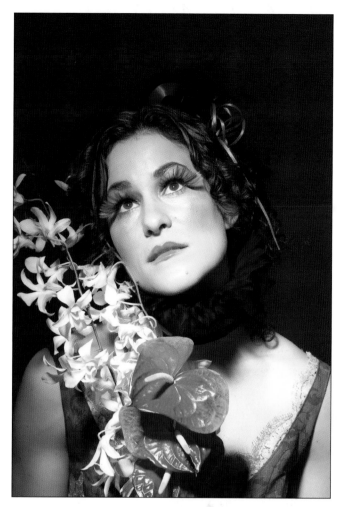

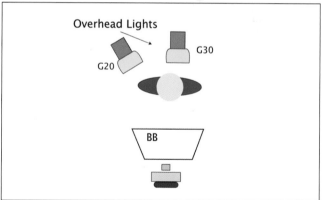

Tools: Mamiya 645AF, Phase One H5, 80mm lens
Lights: two Speedotron 2400 packs, strobe with a 20-degree honeycomb grid, strobe with a 30-degree honeycomb grid, bottom bounce
Power settings: overhead light at full power, strobe fitted with 20-degree honeycomb grid at 25 percent power
Camera settings: manual mode, 80mm lens, shutter speed $\frac{1}{60}$, aperture f/22
Who's on set: photographer, assistant, image stylist, hair stylist, makeup stylist, model

Overhead Light, Part 2

Overhead light is present in our day-to-day lives, so scenes illuminated by overhead light appear natural and pleasing to us. Therefore, overhead light is standard in many photographic scenarios.

When photographing a product, you must create the best-possible, most enticing rendition of the subject. However, you must also ensure that the vision you present holds up off of the set. To represent the product in as realistic a way as possible, use overhead light, then add bounce cards and spotlights as needed. Unless your product is photographed in a realistic manner, you risk creating a discrepancy between the way viewers perceive your ad and the way the product appears in real life—and this can make the consumer feel let down.

People use their sense of sight to analyze color, shape, depth, and weight. Lighting objects from above casts shadows downward and helps viewers determine the girth of the subject. Because many consumers determine the quality of a product, to some extent, by its weight, this approach is often used with smaller, lighter subjects. Remember, the way consumers perceive the mass of the subject is up to you and your client.

You should fine-tune your lighting skills by familiarizing yourself with the way overhead light shines on subjects through scrim and softbox materials. Simply placing a light over your subject does not always create a pleasing effect. You need to fill in shadow areas by bouncing in reflected light. A word of warning: try not to flatten the image by decreasing all the shadows. The presence of shadow creates a feeling of depth.

About the Image. This image was created as a test shot for a potential client. Never be greedy when such an opportunity arises; do your best, and you will land the job. In this case, the image pleased the client and was used in their main advertising piece, and we were paid. The following paragraphs outline the steps we took to create the shot.

Lifting the product up can enhance the effect of the light that is reflected onto it. In this case, we used children's building blocks as a base for the products, then added in the ice-like cubes around the bottom of the products. When photographing tubes, bottles, cans, and other round shapes, watch how this height affects the reflections off of the front of the subject.

To produce the water droplets, I used a water and glycerin mix, applied with a spray bottle.

Two lights and three bounce cards were used in the shot. The main light was a strobe in the P1 position of the light panel, placed overhead. Two side bounce cards and a bottom bounce card reflected light back into the product. Finally, a strobe fitted with a 10-degree honeycomb grid was used to light the background.

In this image, the 35mm lens was stopped down to f/22. Using the smallest possible aperture will allow you to produce the best-possible focus on the products.

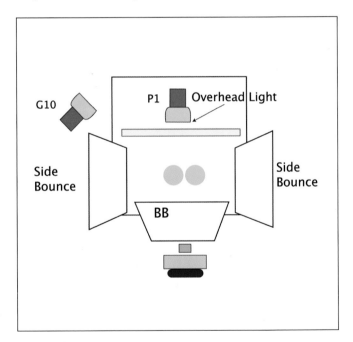

Tools: Mamiya 645AF, Phase One H5
Lights: two Speedotron 2400 packs, panel with strobe in P1 position (overhead), strobe fitted with a 10-degree honeycomb grid, two side bounce panels
Power setting: P1 light at full power, gridded light at 50 percent power
Camera settings: manual mode, 35mm lens, shutter speed 1/60, aperture f/22
Who's on set: photographer, assistant, stylist, client

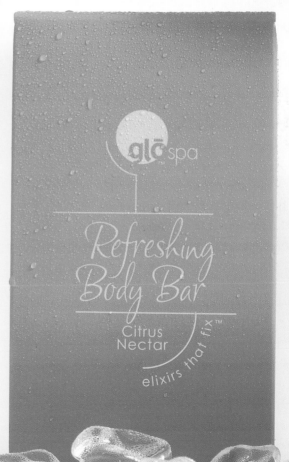

Using Mirrors

Mirrors are a key tool in the creation of a well-lit photograph. You can add light directly to areas that need it without affecting the overall shot. Mirrors offer an exceptional amount of control over your lighting (I use them rather than snoots or barn doors), and detail in lighting is at the very heart of creating images that sell. Another benefit is that when you employ mirrors in your set, you can produce a lot of light without adding another light and stand to clutter up the set.

Have on hand a variety of mirrors in different sizes. Small mirrors can be used in tighter spaces, and the larger ones can be used on location to open up shadow detail or to backlight a model's hair. I have worked with photographers who use round makeup mirrors, small square mirrors, and even broken pieces of mirror with gaffer's tape on the edges. Though each of these options work, makeup mirrors seem to work best for me.

Keep in mind that different mirrors can produce a variety of effects. This is due to the color of the "silvering" (backing) behind the glass and the type of glass that is used. Old mirrors, for example, tend to reflect a warm-toned light. Newer mirrors don't affect the color of the reflected light in the same way. Keep in mind that you can add a gel over the mirror to alter the effect. This allows you to selectively add a little color into the scene without affecting the overall image. As long as it's convincing to the audience, a little color will go a long way.

About the Image. Creating this small set was simple. We used only some aquarium gravel and the subject and shot close to keep the small subject prominent in the frame.

The light employed in an image creates color, as well as the highlights and shadows that allow the viewer to determine the shape and size of an object. The trick to effectively using what I call the "bright spot" technique is to attractively light the subject, then reflect the main light back into the subject using a mirror (a snoot or honeycomb grid can work too). To increase contrast, you can use black cards to block the light from hitting the areas of the subject that you want to keep in shadow.

For this shot, we placed a strobe with a 20-degree honeycomb grid behind and slightly to the camera-left side of the set. This was the main light source. Two mirrors were placed opposite the gridded strobe to reflect light onto the front of the statue. Next, a strobe was positioned on the camera-right side of the set. This light was aimed at the ground and also at the bounce card at the front camera-left area of the set. Four black cards were used to create the long shadows on the set.

Note that the background color of the image is cool and the statue is warm. This creates incredible separation. To create this presentation, we simply combined two images in Photoshop. In commercial photography, speed is the name of the game. Sometimes, it's easier to retouch an image using an image-editing program than to apply the perfect lighting. My advice is, if it is faster to control a reflection or a dark area in the retouching stages of the photograph, then do it. This philosophy applies to all areas of photography but is practiced in the photography of small products every day.

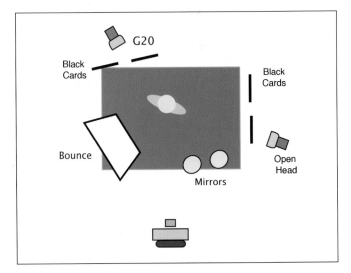

Tools: Mamiya 645AF, Phase One H5, 35mm lens
Lights: two Speedotron 2400 packs, strobe, strobe fitted with 20-degree honeycomb grid, black cards, bounce card, mirrors
Power settings: strobe at 50 percent power, strobe fitted with 20-degree honeycomb grid at full power
Camera settings: shutter speed $\frac{1}{30}$, aperture f/8
Who's on set: photographer, assistant

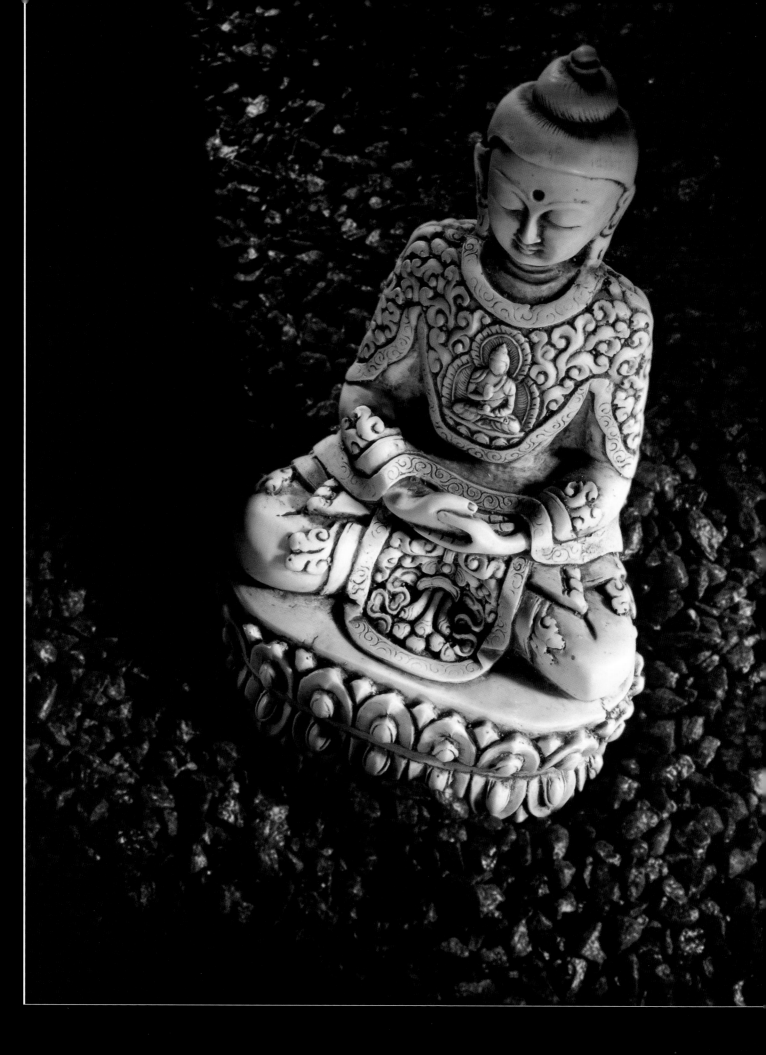

Small Items and Jewelry

Small items and jewelry have always been thought of as difficult to photograph. The techniques that I cover in this section will help you to feel more confident about the job and ease any pressures you may feel.

Remember that the same lighting principles apply to small and large items. If you want to create images that sell, all you have to do is control the light. The size of the set really doesn't matter.

About the Image. To create this image, we first determined the camera angle. (This is important with smaller items because you will not be able to light the subject until you know just where the subject is in the camera.) I'd decided that shooting from the bottom of the keypad and filling the frame with the bottom half of the phone would present an everyday object in a way that people were not used to viewing it. I selected a wide aperture, allowing the focus to fall off toward the back of the phone. This produced an appealing presentation.

To light the cell phone, we placed a panel to camera right and positioned a strobe in the upper-left corner of the light panel, or the P2 position. A bounce card was placed opposite the light. Finally, we placed a mirror to the rear left of the product to fine-tune the light. You may find using bounce cards or black cards produces the desired result with your particular subject.

Though I had a can of compressed air on hand, I wasn't able to remove every speck of dust from the surface of the phone. This problem was made obvious due to the close presentation of the shot. To solve the problem, I simply used the Healing Brush in Photoshop.

I also used Photoshop to add a green tint to the photo, which was originally perfectly neutral. The added color took the shot from okay to great. Using Photoshop isn't cheating. It's simply another tool that photographers can use to intensify their images.

You can use dental wax to prop up small pieces of jewelry. Make sure to allow enough open space for your hands to fit into the set. Always wear gloves to avoid fingerprints.

Tools: Olympus E-500, 14–45mm lens
Lights: Speedotron 2400 pack, panel and strobe in P2 position, side bounce, mirrors
Power settings: P2 at low power
Camera settings: program mode, shutter speed $\frac{1}{125}$, aperture f/8
Who's on set: photographer, client (via e-mail approval)

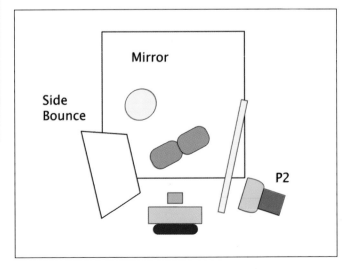

Sure, you can use a bright blast of flash in a dark room to create an image, but the odds of the image looking good aren't in your favor. For outdoor work, however, an on-camera flash is essential for fill.

When the sun is behind your subject, you'll need to add light to fill in the model from the front. To get the best results, find the f-stop that best exposes the natural light, then set your flash for the same exposure. Once you think you have equalized the two exposures, check the results on your camera's LCD screen. Be careful that the highlight areas of the image are not blown out (in other words, ensure that the RGB values are not over 250); otherwise, you'll have a hard time converting the image to CMYK and getting a good print.

While this is an advanced technique, it's one worth mastering. The great outdoors provides photographers with a vast array of interesting locations, and using this fill technique can help you to make a wide variety of settings viable.

About the Image. Looking at this portrait, you'd never guess that this model was positioned in the back of an empty diesel truck. The wood in the background lends great texture to the image. The frosted acrylic top of the truck provided a ready-made diffusion, but because it came from overhead, some unflattering shadows fell on the model's face. To correct the problem, I set the fill flash to match the reading of the ambient light and was able to counter the shadows. This is a perfect example of holding the detail in the highlight areas of the shot.

Tools: Olympus e500, Minolta 2800 AF flash
Lights: natural light diffused by frosted windows, flash
Power settings: on-camera flash at low power, ISO 25
Camera settings: program mode, ISO 25, shutter speed $^1/_{125}$, aperture f/8
Who's on set: photographer, assistant, client, model

Sunlight

Because the sun rotates slowly, the light is ever changing in your set. Therefore, once you have set up your sunlit image, you will need to work quickly.

The main trick to using the sun is to determine what type of light you want in the shot. After you know what you are lighting, block out the sunlight you don't need, and bounce in the sunlight you need. Use a fill flash if possible to soften the shadow areas.

If you want to backlight a model's hair, just have her stand with the sun behind her. You can then bounce the sunlight to illuminate her face and the front of her body. Be careful not to let the sun hit your lens.

You can also use a mirror to catch the sun behind the model and shoot it toward her hair. This allows more flexibility in positioning. You can use a large scrim to soften the light that hits her face, making it easier for her to keep from squinting. I find this to be the most controllable technique for backlighting.

Sunlight can create a few working hazards for the photographer.

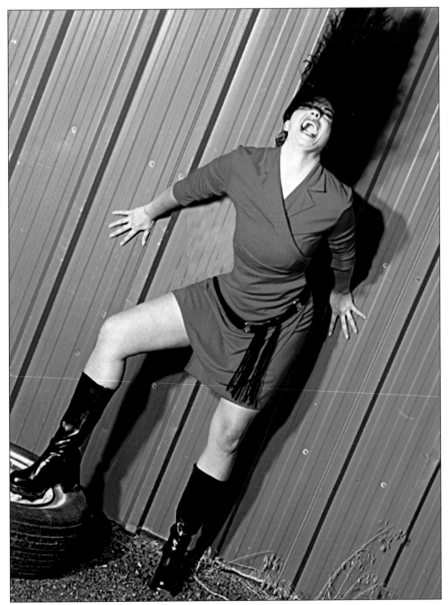

1. The sun makes black equipment super hot.
2. You can get burned after long exposure to the sun.
3. Prolonged exposure to the sun makes your equipment less accurate.
4. The entire photo team can get dehydrated, so bring lots of water.

When shooting at midday, try not to use snow, white sand, concrete, mirrored buildings, or still water as a backdrop. These surfaces can create exposure problems in midday sun. To defend against this problem, you can use portable strobes to light the subject, choose camera angles that reduce the glare, or wait until the sun is in a more desirable position.

The hour after the sun rises and the hour before it sets are ideal times for producing a romantic or warm glow in your photo. This time frame is referred to as the "golden hour." The problem is, these ideal shooting times are short lived. This means you have to have your shot set up and ready to go before sunrise or sunset.

Of course, sunlight also streams through windows and can be used to create indoor shots. Your lights cannot overpower the sun, so be sure to place your lights in the set in a way that evens out the lighting composition.

About the Image. I composed this shot at an angle to amplify the dynamic quality in the image. The tire in the left corner of the frame helped to balance the composition and creates an interesting diagonal. It also help the overall pose, as the model's elevated leg visually enhanced her curves. The model's facial expression also contributes to the success of the image.

To light the image, two umbrellas were placed to camera left and aimed at the subject. They were used at full power and produced enough light to overpower the sun by one stop. The sun provided fill and added a little glimmer to the hair. The light was bright, clear, and punchy—a look that's often used in commercial work.

Certainly, the model's hair adds a great touch to the shot. To freeze her hair required careful timing and a fast shutter speed, but the result was what I wanted.

In Photoshop, I added yellow to the red and green to create a harmonious feel, and increased the saturation.

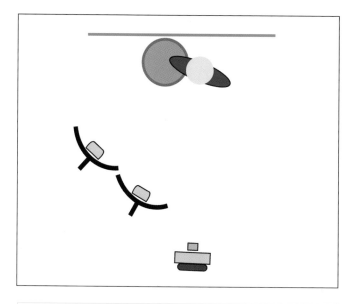

Tools: Mamiya 645AF, Phase One H5, 80mm lens
Lights: Hensel Porty pack, two strobes and two umbrellas
Power settings: undiffused sunlight, two umbrellas at full power
Camera settings: program mode, shutter speed $\frac{1}{125}$, aperture f/8
Who's on set: photographer, assistant, client, model's boyfriend

Tungsten and Daylight Together

Daylight creates a crisp, cool, or natural feel, and tungsten light can be used to warm the edges of your subject. When these light sources are combined in a scene, their light temperatures play off of each other, creating beautiful images. This technique is easy to produce and can be effective when shooting an ad campaign, or any other time you want to create an array of different shots using a uniform lighting approach.

The great thing about this technique is it makes uninteresting items seem interesting. With the proper control of these two light sources, you can use the color variances to define the shape of your subject. Color variances combined with good composition will always make for an interesting image.

The mixed lighting technique can be employed with professional film or digital cameras, but you'll find more variety in the coloration of the image if you are working with film. When using film with the tungsten and daylight combination, try several different films. Use daylight films, then use tungsten films. You will find that the effects are quite different. You can also push the film's development times to create a more granular effect. The more experimentation you do, the better off you are. All the effects you find can then be cataloged, and you can show the various options to your clients.

To use this technique with your digital camera, you must first find your gray balance to correctly capture the daylight source, then you can add your tungsten sources and start shooting. Take a few shots and check your LCD screen to ensure that one light source is not overpowering the other. If the shot appears too warm, turn up the power on the daylight packs and stop down the aperture. Also, try to ensure that the colors do not appear too saturated and unrealistic (unless your client specifically requests that effect). Overly exaggerated, unnatural colors can be the death of an image.

About the Image. To create this shot, I exposed for the tungsten lamps first and then added flash where it was needed. Our main light in this setup was a strobe shot through a light panel in the center, or P1, position.

This light was placed across from the CD shelving unit at the camera-right side of the set. A strobe fitted with a 30-degree honeycomb grid was aimed at the unit from the camera-right front corner of the set. This produced the perfect light on the product. Finally, a third strobe was placed midway between the panel light and the back of the set on the camera-left side of the set. The light this unit cast filled the back portion of the room.

To get the shot just right, I selected a ½ second shutter speed. This allowed me to create the type of glow discussed on page 86 and to bring out detail in the shot. The lamp at the rear of the set was instrumental in creating the feeling that the shot was made in a home, rather than on the sales floor.

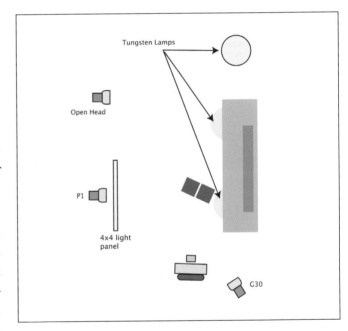

Tools: Mamiya 645AF, Phase One H5, 80mm lens
Lights: two Speedotron 2400 packs, three tungsten lamps, three strobes
Power settings: panel with strobe at the center, or P1, position at full power, strobe fitted with a 30-degree honeycomb grid at 50 percent power, strobe at 25 percent power; two tungsten lamps in cabinet, 60 watts; tungsten lamp on desk, 100 watts
Camera settings: shutter speed ⅟₆₀, aperture f/8
Who's on set: photographer, assistant, two art directors, store manager, general public

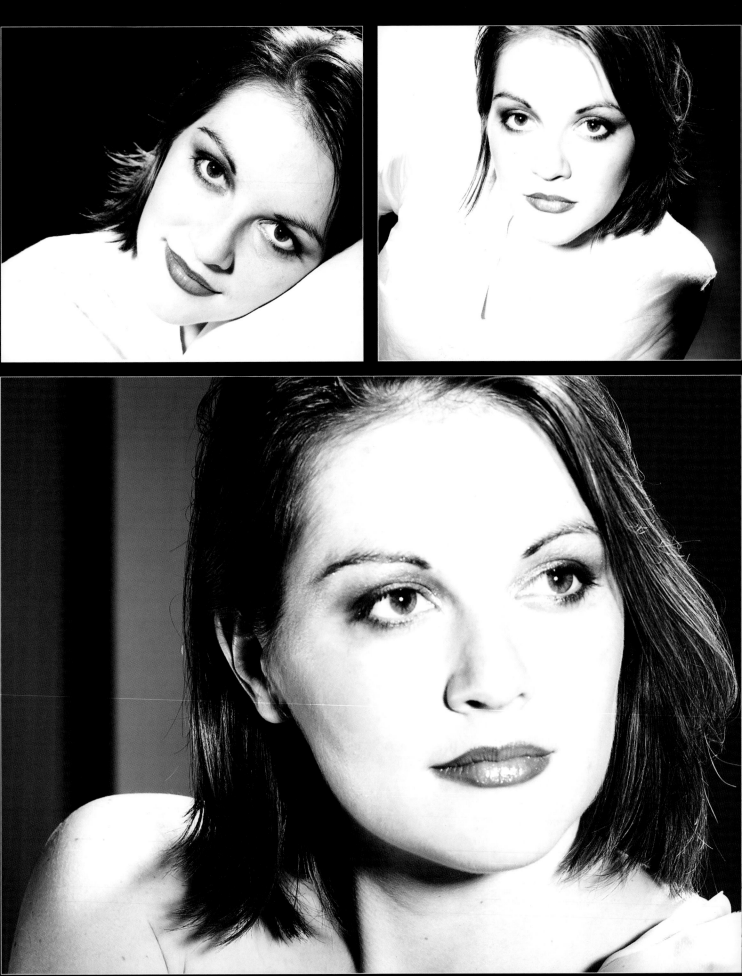

As a commercial photographer, you will often be called upon to create multiple images for an ad campaign. Using light to create a series helps photographers to create a sense of continuity. Select one lighting technique for the job, and stick with it. Should you find that you need to finesse the approach a bit, keep the main light consistent throughout, and then add lights to finesse the exposure as needed. Though the subject may change, the light essentially remains the same, creating a uniform feel from image to image.

The trick is to find out as much as you can about the various subjects you will be photographing. Try to use a simple, effective lighting style that complements all the subjects and is easy to reproduce. You want light that is effective and stylish; this is not the time to overlight the scene.

The images show just one approach at lighting a series. Each client's tastes and needs are different. I urge you to research as much as you can about the product and the company before you make any decisions about the lighting. Try to have your client give you examples of what they are looking for. Above all, listen to the client; they may just tell you everything you need to know. Remember, too, that a happy client will refer other clients. You build your business one job at a time.

An ability to produce a well-designed, effective image series is a sign of a photographer's artistic maturity. I urge you to spend some time working to perfect this skill.

About the Images. Though the model was attractive, I was unsure that the lighting concept I had in mind would suit her. When I tried the diagrammed approach, however, I found that the lighting style suited her perfectly! When you find someone who suits your lighting style, take as many photographs as you can. Keep the light placement constant but vary the intensity, or elements of the set, to produce a plethora of interesting results that you can showcase in your portfolio.

To light the image, we placed a strobe fitted with a 20-degree honeycomb grid to camera right and aimed it at the subject's face. A second strobe fitted with a 20-degree honeycomb grid was placed behind the model on the camera right side of the set. This light provided a glimmer of light on her hair. The softbox behind the model and to camera left was on the floor and pointed up at the model. We chose to place it in view of the camera to produce an interesting background effect. A bounce card placed on the camera-right side was angled toward the client and reflected the soft light from the softbox onto the model's face and side.

To ensure that the model stayed in the light's sweet spot, we positioned her in a chair that remained in a single spot throughout the series, then changed her pose to create a variety of portraits.

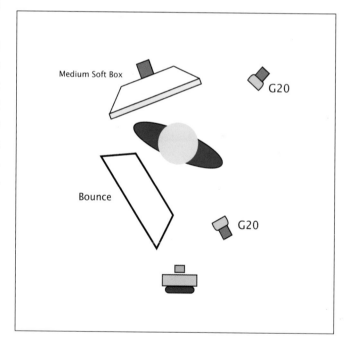

Medium Soft Box

G20

Bounce

G20

Tools: Mamiya 645AF, Phase One H5, 80mm lens
Lights: strobe in medium softbox, two strobes fitted with a 20-degree honeycomb grids, side bounce
Power settings: softbox at 66 percent power, strobe fitted with 20-degree honeycomb grid on model's face at full power, strobe fitted with 20-degree honeycomb grid on model's hair at 75 percent power
Camera settings: shutter speed 1/60, aperture f/16
Who's on set: photographer, assistant, agent, makeup artist, model

Lighting Glass

When photographing glass, you should never reveal where the light is coming from. In many shots, you'll see a large softbox reflected in the subject's surface. This is ugly and should be avoided. Also, make sure the camera and photographer are not reflected in the shot. To prevent this, select a piece of foam core at least 4x4 feet, place it between the camera and the set, and cut a hole in the center to slide the lens through. This will block any reflections from the front of the set.

Also, take care to protect the glass object(s) you are photographing from breakage. Consider placing a cushion around the item for extra protection.

When photographing clear glass, slightly underexpose the shot. It is better to gray the white information than to lose detail in the whites. After all, you can go into Levels in Photoshop to finesse the exposure. If, during the shoot, you find that certain areas of the subject are too bright, you can use a gray or black card to reflect darker shades into the glass.

The following technique can be used to photograph all types of reflective products.

About the Image. To light the subject, I placed panels in the left and right front corners of the set. A strobe was placed in the P1 position on the camera-left side. A strobe was added in the P2 position of the panel located at camera right. A strobe fitted with a 20-degree honeycomb grid was placed in the camera-right back corner of the set and directed at the subject. Top and bottom bounce cards reflected a soft quality of light.

I selected a 35mm lens to get a higher, more dimensional view of the bottle. This allowed me to heighten the interest without adding to the cost of the shot.

Photoshop played an important role in creating this image. We worked with only one bottle on the set, then added in the second and third bottles digitally. The bottles were slightly blurred to achieve the shallow depth of field effect. The background for the image was also created in Photoshop. It's an enlarged section of the original bottle, with a drop shadow added to the shot.

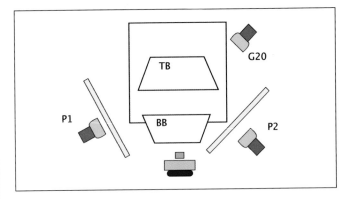

Tools: Mamiya 645AF, Phase One H5, 35mm lens
Lights: panel with strobe in the P1 position, panel with strobe in the P2 position, strobe fitted with 20-degree honeycomb grid, top bounce, bottom bounce, two Speedotron 2400 packs
Power settings: P1 at full power, P2 at ¾ power, G20 at ½ power
Camera settings: shutter speed 1/60, aperture f/4.0
Who's on set: photographer, assistant

Lighting photographs should be an enjoyable event for you and your client. You should never become frustrated when lighting a subject. Some subjects are more difficult to light than you might imagine. If you get in a jam while lighting a certain subject, take a break and think it through. Don't be afraid to discuss the problem with your client. They won't think you are stupid. Remember, you're not a superhero, you're a professional photographer. Many times, the client will relate to your frustration and help you to work through the lighting adjustments. Just express to them that the technique you have been using doesn't seem to be doing the trick and that you are going to try something new. Once you have mentioned this, your client will probably enjoy the shoot even more. Showing the client the evolution of your lighting approach will never hurt the relationship.

I recommend that all photographers study the effects of light on many different surfaces and materials during their downtime. There is no better way to lose a client than to putter around a set trying to produce something with unknown results. Practicing without clients around helps you when you come across these materials in the line of duty. Lighting chrome, glass, black neoprene, and other surfaces common to product photographers can be challenging. Even a paper bag can be difficult if you light it wrong.

You should also get your portrait techniques down to a science. There will come a time when you have to photograph a person with a large nose, deep inset eyes, glasses, and a bald and shining head—or a group of individuals with a variety of perceived flaws. You don't want to ask your subject(s) to lean in different directions until the light seems correct. Directing people can be the hardest part of a photo shoot. So bring in a few of your friends and have them put on some glasses and try directing them. Even better, put a pair of glasses on three balloons and try to get a great shot without ugly reflections.

Also, never let a portrait subject know you are having a difficult time lighting them. People want to feel special when they are being photographed. When you can comfortably work through the session, you can reassure your clients that they're doing great and help calm their nerves.

As a commercial photographer, it is critical that you practice your photographic approach. It's your job to understand light and its effects on people and materials. Photography is highly competitive, and each of us needs to be able to light and deliver great photographs on demand to our clients. Practicing does not mean that you are a bad photographer. On the contrary, a photographer who does not practice could be left behind.

Glossary

Acrylic diffuser—Semi-opaque white piece of acrylic used between light source and photographic subject, used to evenly and softly diffuse light from the light source.

Backlight—Light source that illuminates the back of the subject and points toward the camera. This type of lighting often causes the front of the subject to appear in shadow, and its use may result in underexposure. The edges of the subject lit in this manner may appear to glow; this effect is commonly referred to as rim lighting.

Black card—Device used to block light from hitting the set or subject.

Boom—An adjustable pole-like arm used to hold lights or lighting accessories.

Bounce card—A white card that is used to bounce light back into set from another light source.

Bounce light—Light that does not travel directly from the source but reflects off of something before hitting the subject.

Bright spot—The brightest highlight area in an image.

Camera stand—A device with a cross arm designed to hold cameras of all sizes in the studio. This stand usually has a locking wheel base and measurements that allow the photographer to calculate the camera position.

Color temperature—Description of the color quality light, measured in degrees Kelvin (e.g., 5500K).

Cookie—A device placed in front of a spotlight to create a pattern of light on a set or subject.

Dappled light—Atmospheric lighting that adds form and shape to the image. See *Cookie*.

Daylight—Light measured at 5500–6500K produced by the sun or a strobe.

Falloff—Loss of illumination toward the edges of a scene, due to the use of a light source that does not cover the entirety of the set or view.

Fill light—A secondary light used to fill in the shadows created by a main light. Usually has a lower luminosity than the main light.

Flare—Flare is the non–image forming light that is recorded by the camera. It can be caused by light that is directly hitting the lens or bouncing off a surface into the lens and can result in characteristic shapes and lines in the image.

Flash—These lights are the tool of choice for most studio photographers. They run cool, are portable, and pair easily with daylight film or your digital camera's daylight white balance setting. The term also refers to the bright burst of light produced from lights.

Gel—Colored plastic that you place in front of lights or on a bounce card to alter the color of light on the set or subject.

Hair light—A light placed over the subject to show detail in the hair.

Highlight—The bright, shadowless areas that result when a light hits the subject or set.

Honeycomb grid—A modifier that typically fits inside the reflector dish and forces the light to travel in a straight line. The most popular types are the 10-, 20-, 30-, and 40-degree grids, but some manufacturers offer an ultraprecise 5-degree honeycomb grid.

Lighting schematic—A drawing of lighting setups used to communicate the lighting strategy with other photographers or clients.

Light panel—A large white translucent fabric panel with a steel frame. By shooting light through the panel, a soft, diffuse light source is produced.

Light ratio—The difference in the intensity of the shadow versus the highlights in the image.

Main light—The most powerful luminous source lighting the set.

Overhead light—Light source that originates from above the subject or set.

Power pack—The source that powers strobes. A power pack may be connected directly or indirectly to your flash units.

Scrim—A panel made of translucent material that disperses the light cast through it.

Secondary light—The second most powerful luminous source lighting the set.

Set—Any space that is in the camera view when taking a photo.

Shadow—An area of the scene or subject that is not illuminated directly by the light source. Such areas of the composition are darker than areas that receive light.

Side light—A light that is positioned to the side of a subject or set. This light has a dramatic quality and can be useful when creating a sense of dimensionality in the image.

Softbox—A large fabric housing for the light source that produces a soft, diffuse quality of light.

Studio stand—A heavy-duty stand, often on wheels, that can hold lights, clamps, bounce cards, or black cards.

Snoot—A long tube attached to a light source to produce a narrow beam of illumination.

Subtractive lighting—A lighting technique in which a black card or panel is used to block light from one area to better define the light ratio in the scene.

Sync cord—A connection between the camera and the flash unit that allows the flash to fire at the precise moment when the shutter is fully open so that the full effect of the flash burst is recorded.

Tabletop set—A set that includes a flat, elevated surface upon which small objects and products are typically photographed.

Tripod—A three-legged stand that is designed to hold a camera. Its use can prevent the image-blurring camera shake that can result with longer shutter speeds when you're handholding a camera.

Tungsten—Light measured at 2500–3500K produced by an incandescent light source.

Umbrellas—This umbrella-shaped modifier is clipped or mounted onto a light to diffuse and soften the light falling on a subject or set. These modifiers are available with a silver lining for cooler light, gold for warmer tones, or a white interior, which creates a higher level of diffusion but does not impact the color of the light produced.

Wraparound lighting—A soft light produced by an umbrella or other modifier that hits both sides of the subject. This type of lighting produces a low lighting ratio and well-illuminated, open highlight areas.

Index

A
acrylic diffuser, 27, 86, 115, 124
Adobe Photoshop, 77, 80, 84, 86, 89, 90, 114
angle of view, 14
aperture, 12, 13, 14, 74, 86, 114, 118
automobiles, 94–97

B
backlight, 8, 11, 112, 117, 124
black cards, 17, 79, 84, 87, 112, 114, 125
bounce cards, 17, 26, 94, 100, 108, 109, 110, 122
black & white images, 79
boom stand, 16, 82, 90, 95, 100, 108, 109, 124
bright spot, 112, 124

C
camera angle, 83
camera selection, 15
cleanliness, 26, 78, 87, 94, 95, 100, 104, 107
color temperature, 9, 10, 14, 124
meter, 14
cookie, 18, 124
compressed air, 107, 114
corporate images, 82, 83

D
dappled light, 18, 78, 87, 124
daylight, 7–10, 115, 124
depth of field, 12, 14, 77, 87, 122

E
elderly subjects, 104–5
exposure, 12–14

(exposure, cont'd)
aperture, 12, 13, 14, 74, 86, 114, 118
histograms, 13
light meters, 13–14
color temperature, 14
flash, 14
incident, 13
reflected light, 13–14
shutter speed, 13

F
falloff, 124
fill light, 115, 124
flare, 84–86, 124
flash, 8–9, 14, 15, 87, 92, 96, 99, 100, 106, 115, 124
fill, 115, 124
meter, 14
power packs, 15, 87, 92, 96, 99, 100, 106, 124
food, photographing, 87

G
gels, 80, 104, 124
glass, photographing, 23, 26–27, 94, 122

H
hair light, 124
highlights, 115, 124
honeycomb grids, 16, 40–45, 124

L
LCD screen, 115, 118
lenses, 12–13, 14, 15, 18, 83, 84, 86, 89, 122
light, characteristics of
color temperature, 10, 124
hard vs. soft, 11–12

(light, characteristics of, cont'd)
direction, 10
lighting schematic, 124
light modifiers, 15–18
acrylic diffusers, 27, 86, 115, 124
black cards, 17, 84, 87, 112, 114
bounce cards, 17, 124
cookies, 18
gels, 124
honeycomb grids, 16, 40–45, 124
mirrors, 16, 18, 94, 112
panels, 17, 30–39, 124
reflectors, 16
softboxes, 16–17, 60–72, 125
umbrellas, 17, 46–59, 125
light, types of
artificial, 8–10
flash, 8
fluorescents, 10
HMI lights, 10
strobes, 8–9
tungsten light, 9–10, 118, 125
casual, 74
dappled, 78, 124
dramatic, 77
natural, 7–10, 16, 56, 96, 97, 105, 115, 117, 124
golden hour, 8
overhead light, 7–8, 108–10
window light, 8
liquids, photographing, 100
location sessions, 102

M
main light, 124
makeup, 74, 109

medical shots, 104

meters, light, 13–14

mirrors, 16, 18, 94, 112

mixed lighting, 118

models, 25, 74, 83, 92, 102, 104–5, 106, 109

O

outdoor sessions, 8, 11, 56, 74, 102, 115

overhead light, 7–8, 108–10, 124

P

panels, 17, 30–39, 124

patients, photographing, 104–5

perspective, 82, 83

portraits, 81, 82, 83

power pack, 15, 87, 92, 96, 99, 100, 106, 124

R

ratio, light, 124

reflections, 26, 56, 84, 122

release forms, 102

rooms, photographing 25, 88–93, 99

S

safety, 17, 25, 56, 74, 87, 99, 100, 105, 109

scientific shoots, 106

scrim, 110, 117, 125

set; see studio setups

secondary light, 125

side light, 11, 26, 125

series, 121

shadows, 115, 124, 125

shutter speed, 13

small items, photographing, 114

snoot, 125

softboxes, 16–17, 60–72, 125

stands, 17, 124, 125

studio setups, 23–27, 125

 inexpensive sets, 27

 larger sets, 24, 99

 reflective sets, 26

 room sets, 25

 simple product setups, 23

subtractive lighting, 17, 79, 84, 87, 112, 114, 125

sunlight, 7, 16, 56, 96, 97, 105, 117

sync cord, 125

T

test shots, 99

tripod, 125

tungsten light, 9–10, 118, 125

U

umbrellas, 17, 46–59, 125

W

water, 100

wraparound lighting, 92, 125

OTHER BOOKS FROM
Amherst Media®

MASTER LIGHTING GUIDE

FOR PORTRAIT PHOTOGRAPHERS

Christopher Grey

Efficiently light executive and model portraits, high and low key images, and more. Master traditional lighting styles and use creative modifications that will maximize your results. $29.95 list, 8½x11, 128p, 300 color photos, index, order no. 1778.

POSING FOR PORTRAIT PHOTOGRAPHY

A HEAD-TO-TOE GUIDE

Jeff Smith

Author Jeff Smith teaches surefire techniques for fine-tuning every aspect of the pose for the most flattering results. $34.95 list, 8½x11, 128p, 150 color photos, index, order no. 1786.

PROFESSIONAL MODEL PORTFOLIOS

A STEP-BY-STEP GUIDE FOR PHOTOGRAPHERS

Billy Pegram

Learn how to create dazzling model portfolios that will get your clients noticed—and hired! $29.95 list, 8½x11, 128p, 100 color images, index, order no. 1789.

THE BEST OF PHOTOGRAPHIC LIGHTING

Bill Hurter

Top professionals reveal the secrets behind their successful strategies for studio, location, and outdoor lighting. Packed with tips for portraits, still lifes, and more. $34.95 list, 8½x11, 128p, 150 color photos, index, order no. 1808.

RANGEFINDER'S PROFESSIONAL PHOTOGRAPHY

edited by Bill Hurter

Editor Bill Hurter shares over one hundred "recipes" from *Rangefinder's* popular cookbook series, showing you how to shoot, pose, light, and edit fabulous images. $34.95 list, 8½x11, 128p, 150 color photos, index, order no. 1828.

MASTER'S GUIDE TO WEDDING PHOTOGRAPHY

CAPTURING UNFORGETTABLE MOMENTS AND LASTING IMPRESSIONS

Marcus Bell

Learn to capture the unique energy and mood of each wedding and build a lifelong client relationship. $34.95 list, 8½x11, 128p, 200 color photos, index, order no. 1832.

PROFESSIONAL PORTRAIT LIGHTING

TECHNIQUES AND IMAGES FROM MASTER PHOTOGRAPHERS

Michelle Perkins

Get a behind-the-scenes look at the lighting techniques employed by the world's top portrait photographers. $34.95 list, 8½x11, 128p, 200 color photos, index, order no. 2000.

MORE PHOTO BOOKS ARE AVAILABLE

Amherst Media®
PO BOX 586
BUFFALO, NY 14226 USA

INDIVIDUALS: If possible, purchase books from an Amherst Media retailer. Contact us for the dealer nearest you, or visit our web site and use our dealer locater. To order direct, visit our web site, or send a check/money order with a note listing the books you want and your shipping address. All major credit cards are also accepted. For domestic and international shipping rates, please visit our web site or contact us at the numbers listed below. New York state residents add 8% sales tax.

DEALERS, DISTRIBUTORS & COLLEGES: Write, call, or fax to place orders. For price information, contact Amherst Media or an Amherst Media sales representative. Net 30 days.

(800)622-3278 or (716)874-4450
FAX: (716)874-4508

All prices, publication dates, and specifications are subject to change without notice. Prices are in U.S. dollars. Payment in U.S. funds only.

WWW.AMHERSTMEDIA.COM
FOR A COMPLETE CATALOG OF BOOKS AND ADDITIONAL INFORMATION